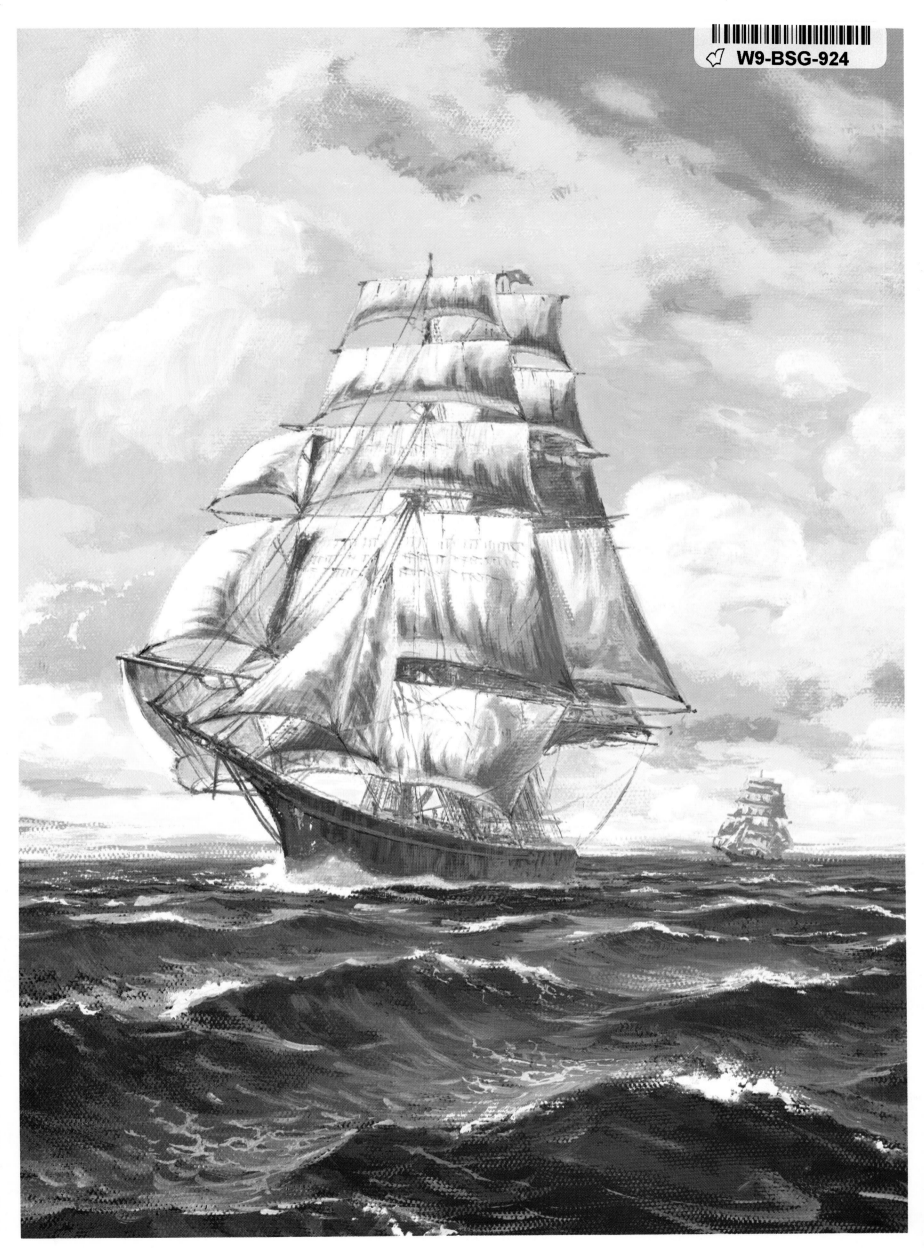

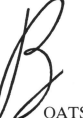OATS! Big ones, little ones, some for pleasure such as rowing boats, luxury cruisers, yachts, punts, etc., others for work such as fishing boats, lobster and shrimp boats, and others carrying a variety of cargo.

Nearly every country in the world that has a coast line or inland lakes and rivers, has boats of one description or other. They come in all sorts of colors and sizes but basically they are nearly all one shape and from an artist's point of view, a beautiful one. Boats are loved by most people whether to use, look at, or photograph and paint. Few things are more paintable than boats, nor scenes more picturesque than harbours with boats dotting the water.

In the following pages I have attempted to show the reader how to paint boats and make beautiful pictures of them. I have sketched several kinds you are likely to see around. On some pages I have shown photographs of typical harbour scenes which I have adapted as paintings.

When you paint from a photograph never copy it exactly, because a pleasing composition is always very limited. You can only photograph what is there. The artist must always try to improve on it. Idealize whatever you see. Use a photograph or transparency purely to base your final composition on. Make your painting a thing of beauty, your creation. We call this artists license, but we cannot take liberties with boats in quite the same way. They are such subtle shapes and they must be drawn correctly, otherwise they will never look right, and so spoil your picture. Try to combine accuracy of definite shapes with a general overall esthetic quality. Many of the best artists can do this quite well, and so will you with practice. As with everything else, observation and discerning is the secret of knowing how.

Some artists like to take their sketch pads out with them and make quick sketches, prior to doing a more finished painting in the studio. Others like to take a camera, and make colored prints or transparencies. Walter Foster has a book on — "Painting from your Transparencies" which you will find invaluable, while a third group of artists prefer to take an easel and do a complete painting on location. Do which ever you prefer, so long as you enjoy doing it, but follow the instructions of this book and you won't go far wrong.

You will find several completed paintings with step by step drawings to help you. Most of the paintings are in gouache (opaque water color) combined with transparent water color, a few paintings are in oils.

Use whichever medium you feel happiest with, whether it be water-color, gouache, oils, acrylic or pastel. Again you will find Walter Foster's books invaluable in showing you how to handle different mediums. Each medium requires a different approach, each is rewarding in its own way. I sincerely hope this book will bring to the reader many happy hours of painting.

KIND ACKNOWLEDGEMENTS TO—
 Ariel Press Ltd. London.
 George G. Harrap & Co. Ltd. London.
 Frederick Warne & Co. Ltd. London.
FOR PERMISSION TO USE
 Technical Reference
 & Make Adaptations

Sincerely yours,

Ralph S. Coventry

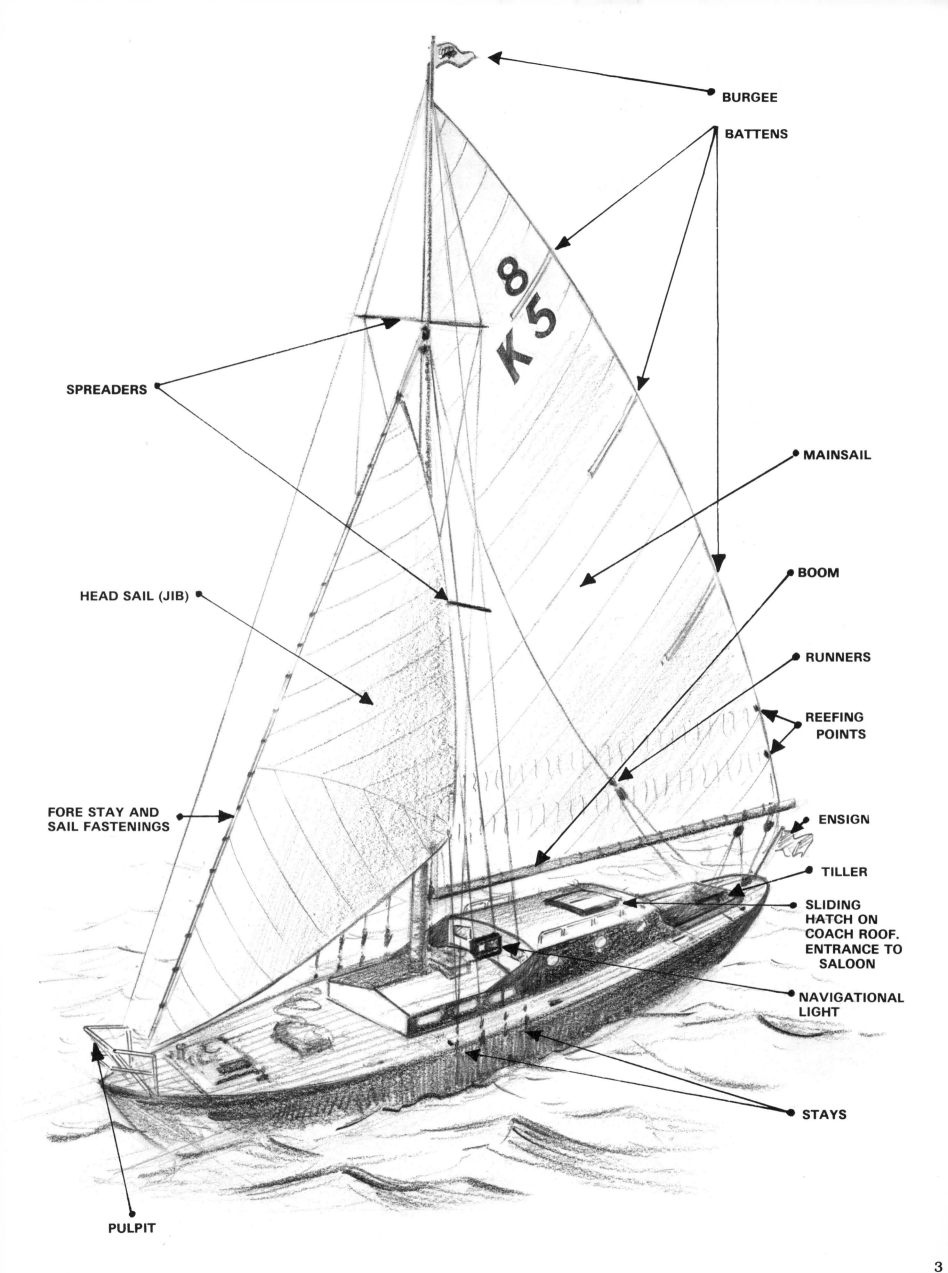

BURGEE

BATTENS

SPREADERS

MAINSAIL

HEAD SAIL (JIB)

BOOM

RUNNERS

REEFING POINTS

FORE STAY AND SAIL FASTENINGS

ENSIGN

TILLER

SLIDING HATCH ON COACH ROOF. ENTRANCE TO SALOON

NAVIGATIONAL LIGHT

STAYS

PULPIT

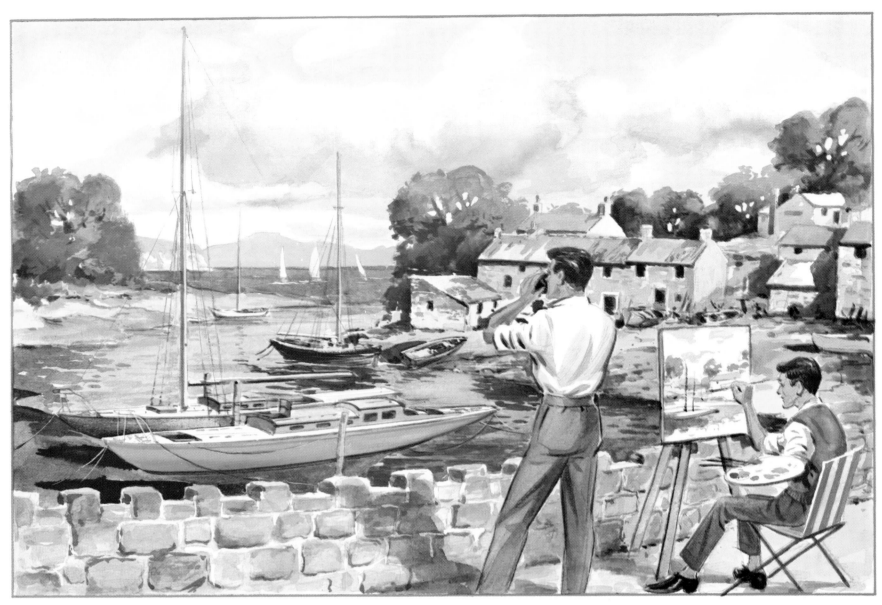

The illustration above shows two approaches to marking a painting one artist is seen sitting at his easel marking a preliminary painting prior to doing a more finished painting in the studio. Another artist is seen taking a 35MM transparency shot which he will project into a shadow box.

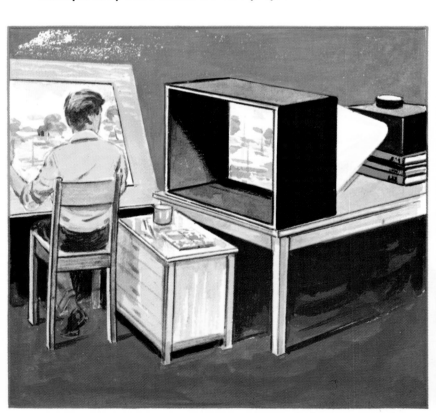

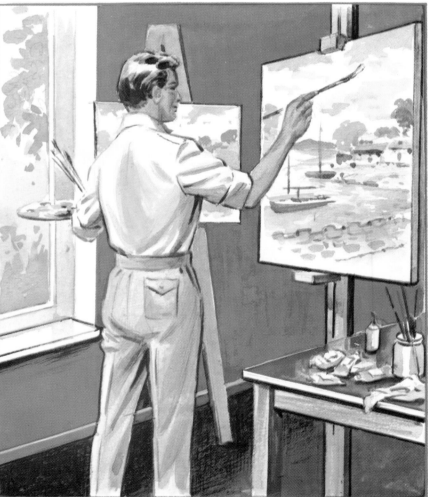

Doing your preliminary sketch on the spot is the old well tried method. Some artists even do a completed final picture this way, a few of us feel a bit self conscious working in the open, especially with someone looking over your shoulder, so the camera is very handy for recording any scene at will. And also—it saves a lot of time.

The lower left illustration shows one artist completing his painting from his projecting transparency, while the artist on the right works from his sketch.

TRANSPARENT WATER COLOR EXERCISE

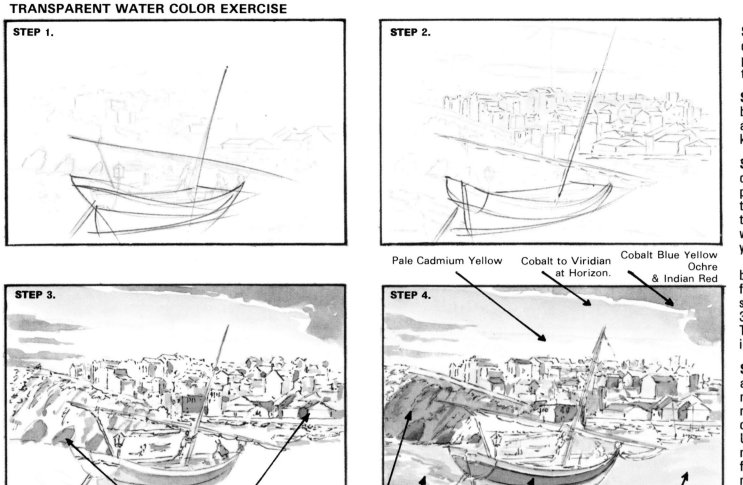

STEP 1.

STEP 2.

STEP 3.

All shadow areas indigo & crimson

STEP 4.

Pale Cadmium Yellow Cobalt to Viridian at Horizon. Cobalt Blue Yellow Ochre & Indian Red

Indian Red Viridian Crimson Ultramarine Indigo & Indian Red Raw Sienna & Vermillion

STEP 1. When you have decided on the best composition, lightly pencil in the main elements.

STEP 2. Outline all the buildings, boats, etc. with a waterproof sepia ink, keeping the line fairly free.

STEP 3. Run pale wash of cobalt blue changing to pale green blue. Using touch of viridian towards the horizon, paint in clouds with mixture of cobalt blue, yellow ochre and indian red.

In all color mixtures the basic color is mentioned first and generally only small quantities of 2nd and 3rd colors should be added. The shadow sides of buildings are indigo and crimson.

STEP 4. The sunlit areas are painted in pale cadmium yellow wash. Also roofs of buildings plus orange mixed with white. Use—viridian and raw sienna for foliage. Indian red for rocks. Sand is raw sienna and vermillion wash. Shade in with darker tones for texture.

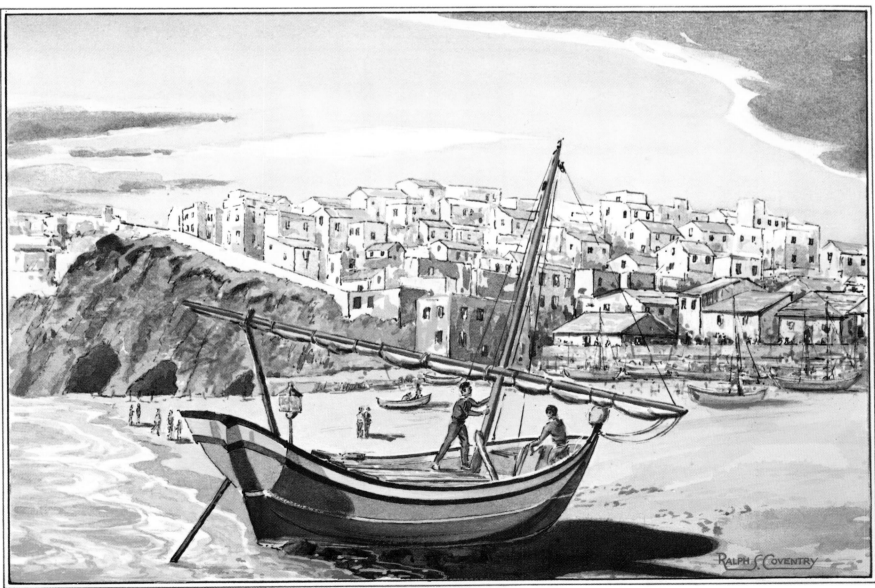

PORTUGESE FISHING VILLAGE

Paint water with viridian, touch of prussian blue, indigo for darker tones, fishing boat in foreground, ultramarine cadmium yellow, crimson for hull masts, yellow, orange, burnt umber and sepia for unpainted wood parts. Sails pale raw sienna, and sepia.

On this page are a few examples of what you can do in the way of pictorial arrangement or composition. These have all been adapted from photographs I took showing various boat and harbour scenes, you can use these if you like, or work out something similar yourself, but always remember to make your pictures look interesting, have a focal point of interest, make sure all the elements are balanced never divide your picture exactly in the middle, strive for harmony of line and color.

It is always a good idea to do—small preliminary sketches in black and white, rendering either in pencil, or wash medium, this helps you to get the correct tonal values in the right places. A correct and well balanced composition will then result.

When you make your final painting in color, your black and white sketch will be invaluable as a guide for tonal values, as well as linear composition.

You will find some suggested color - compositions which I have done from photographs shown along side on . . pages 12 and 13. Compare the tonal values in black and white on this page. You will notice how one can actually get the effect of color in black and white values. The more you practice black and white exercises, the more you will succeed with color.

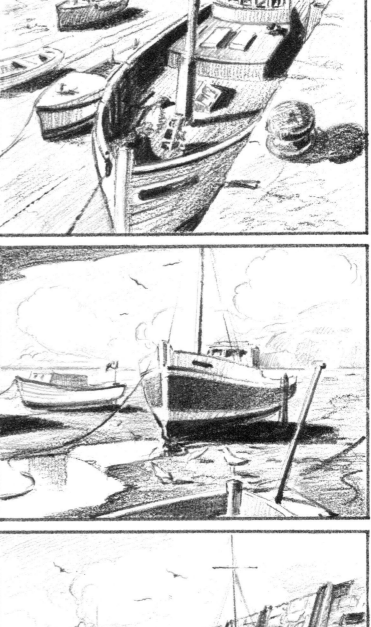

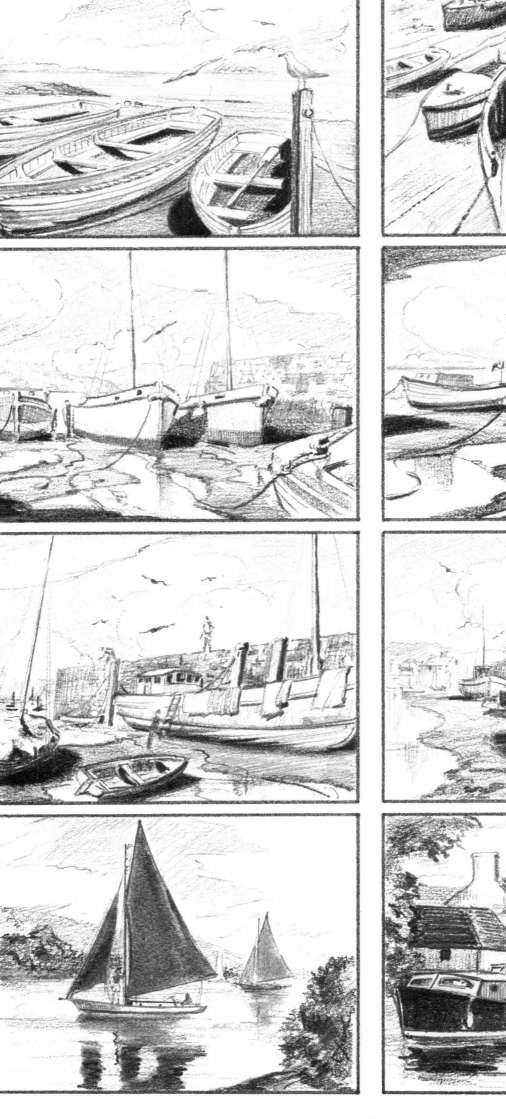

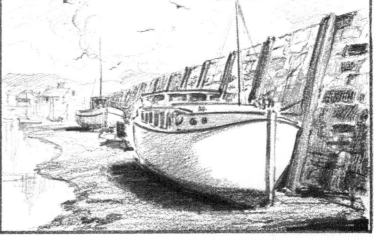

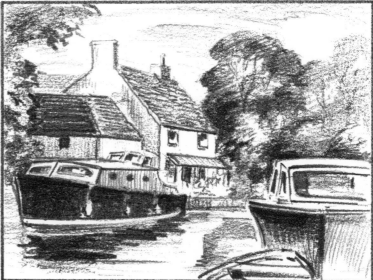

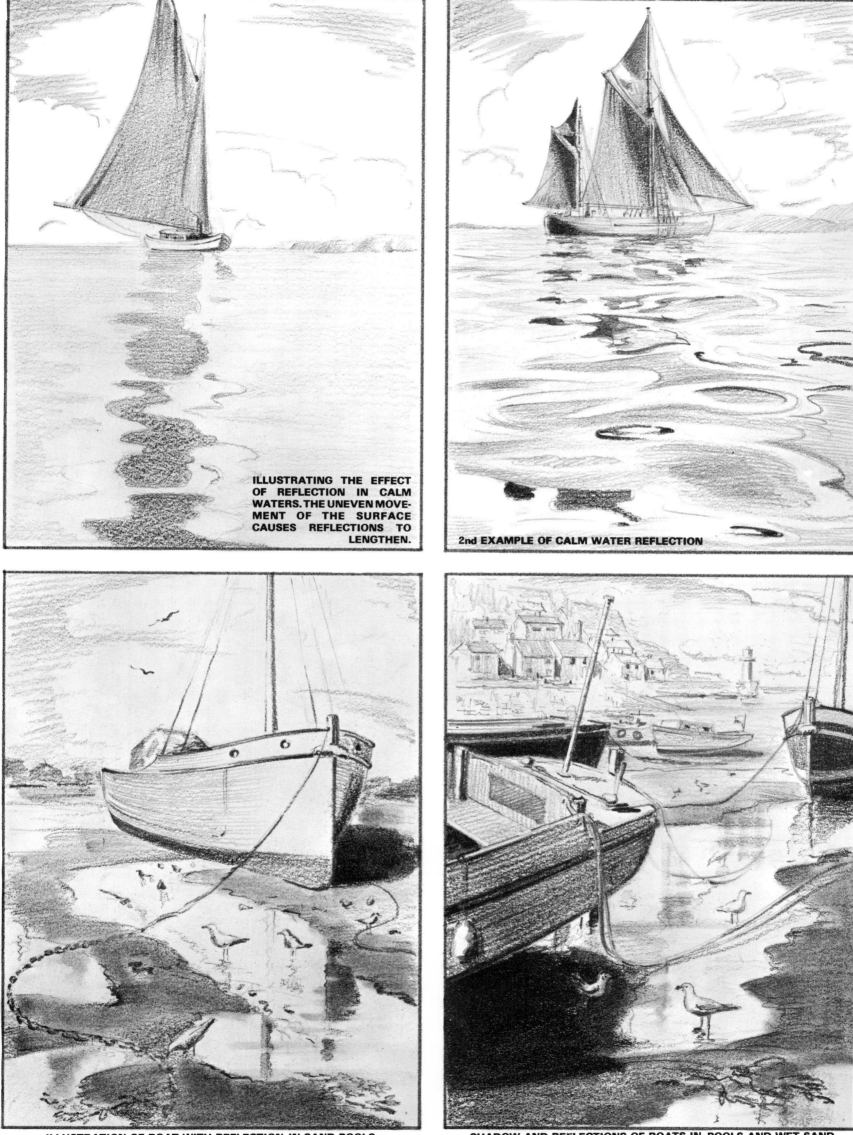

ILLUSTRATING THE EFFECT OF REFLECTION IN CALM WATERS. THE UNEVEN MOVEMENT OF THE SURFACE CAUSES REFLECTIONS TO LENGTHEN.

2nd EXAMPLE OF CALM WATER REFLECTION

ILLUSTRATION OF BOAT WITH REFLECTION IN SAND POOLS

SHADOW AND REFLECTIONS OF BOATS IN POOLS AND WET SAND

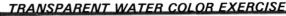

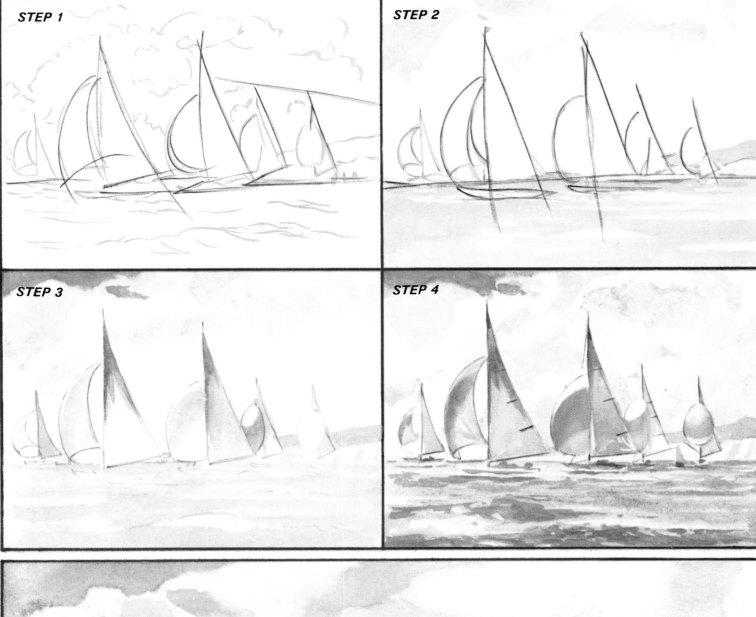

STEP 1

STEP 2

STEP 3

STEP 4

STEP 1

Sketch in lightly the composition you decide on then moisten the whole surface with water and lightly blot it so that it is just damp enough to run the color on.

STEP 2

Wash in the sky with cobalt blue starting darker at top of picture and gradually getting lighter. Slightly greener towards the horizan. Use viridian green to give slight greenish cast. Wash in distant coast line using cadmium yellow and ultra marine mixed to make green areas. Lightly paint in a blue-grey tone. Paint in preliminary tone of viridian on sea, leaving white areas to suggest foam.

STEP 3

Wash in shadow areas of clouds with cobalt blue and indian red. Gradually wash in shadow area of boats, building up to next stage.

STEP 4

Wash in very pale wash over clouds to give a warm effect. On the boat sails gradually build up tones to the right strength and paint in the masts. Use orange, raw sienna and sepia in the shadows. Use sepia for the riggings. For deck details and figures use grey and brown with touches of brighter colors for accent.

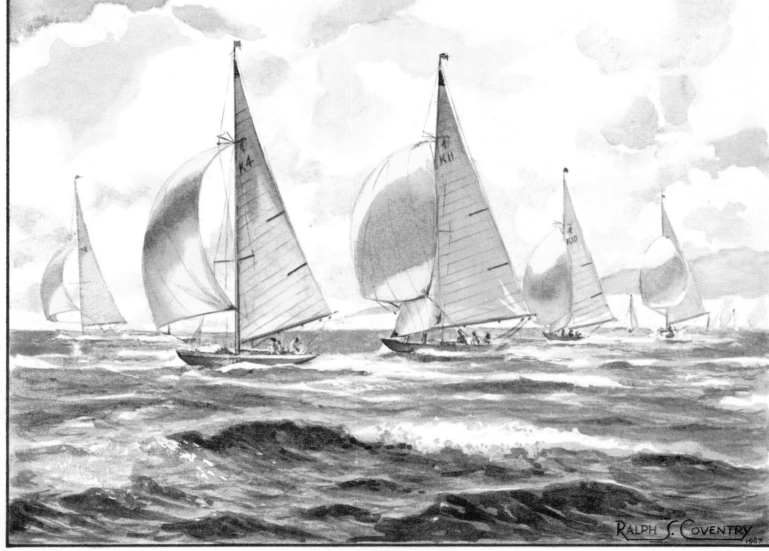

RUNNING BEFORE THE WIND

French ultramarine is used to model the waves. Use your rose madder and viridian for the shadows on the waves, and use touches of white to accentuate the foam. You will find you achieve distance by a semi-opaque wash of white over the background.

STEP 1

Sketch in your yachts lightly, pay attention to rigging. Indicate clouds, and surface formation of waves.

STEP 2

Paint in sky after first dampening the whole surface with water. Start at top of sky with wash of cobalt blue, gradually getting lighter, and a little greener near horizon. Use a touch of viridian for green. Paint in preliminary tone on water in viridian.

STEP 3

Paint in sails. Touch of naples yellow with white for light areas white mixed with a touch of blue and raw umber for darker tones. Blue sails, paint in antwerp blue, keep all tones lighter in distance. Shade white area of hulls in grey with a touch of blue, use cadmium red for yacht in distance.

STEP 4

Masts orange, with raw sienna, sepia shadows. Rigging sepia. Don't make rigging look too hard, suggest it in places. Indicate deck detail, crew etc., in tones of grey blue, sepia, etc. Add french ultramarine to model waves. Rose madder & viridian for shadow side of waves. Use white for foam and spray. Cobalt and indian red for cloud shadows. Paint in pale tonal wash of naples yellow over clouds to give warm effect.

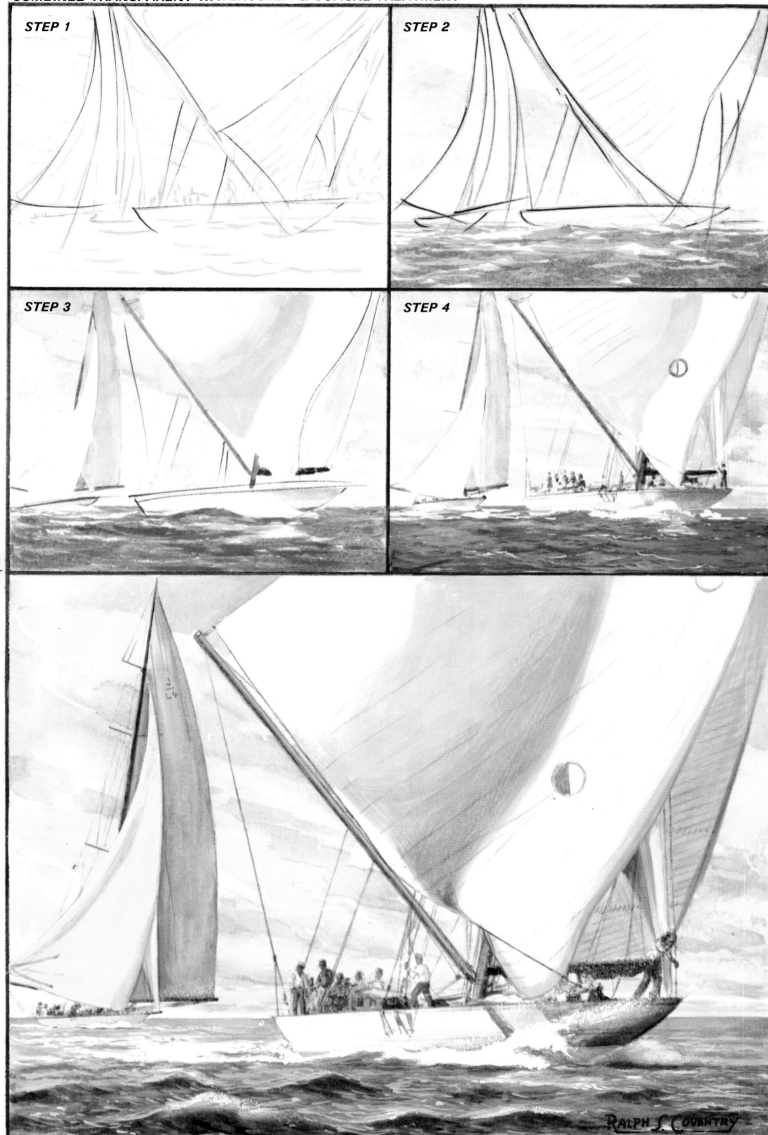

THE RACE

The final stage shown in the finished painting consists of refining details. It depends just how far you want to take your picture. Detail is alright as long as you don't lose the feeling of freedom. A semi-opaque wash over the sky will achieve distance.

WAVE FORMATIONS AND REFLECTION IN SEASCAPES

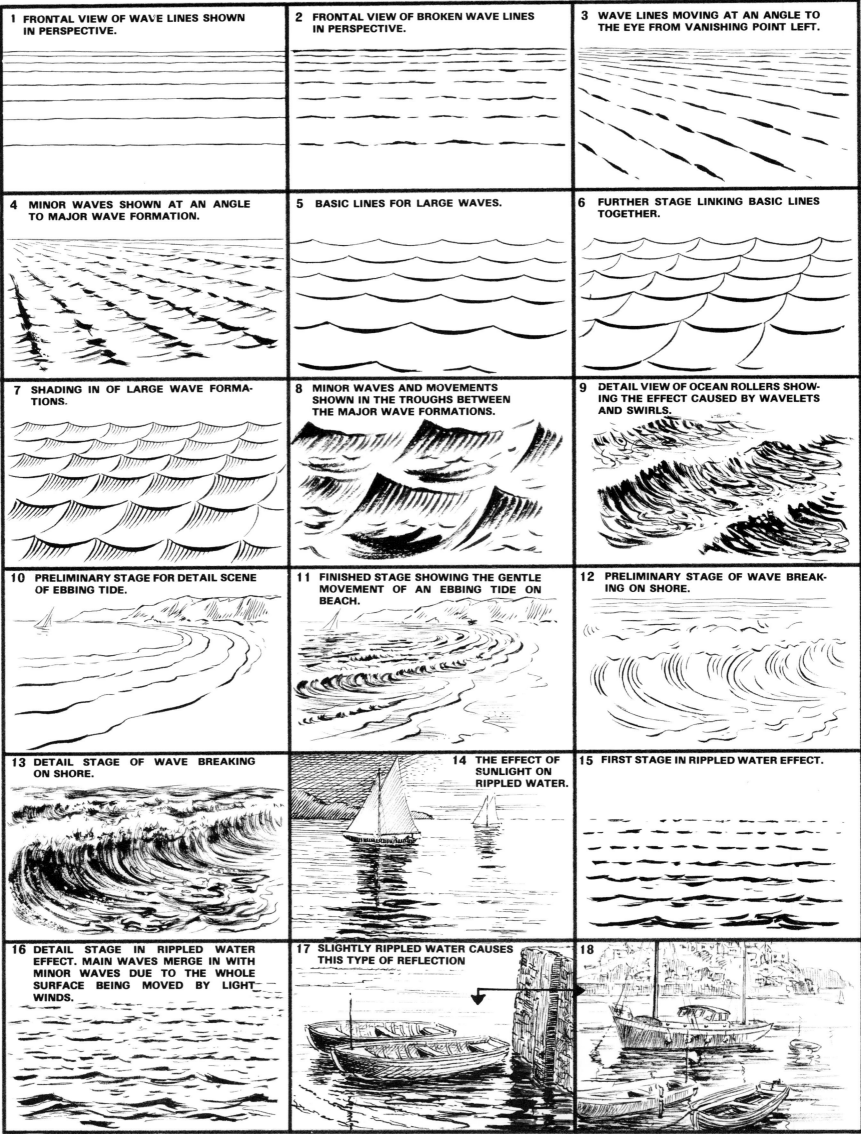

1 FRONTAL VIEW OF WAVE LINES SHOWN IN PERSPECTIVE.

2 FRONTAL VIEW OF BROKEN WAVE LINES IN PERSPECTIVE.

3 WAVE LINES MOVING AT AN ANGLE TO THE EYE FROM VANISHING POINT LEFT.

4 MINOR WAVES SHOWN AT AN ANGLE TO MAJOR WAVE FORMATION.

5 BASIC LINES FOR LARGE WAVES.

6 FURTHER STAGE LINKING BASIC LINES TOGETHER.

7 SHADING IN OF LARGE WAVE FORMATIONS.

8 MINOR WAVES AND MOVEMENTS SHOWN IN THE TROUGHS BETWEEN THE MAJOR WAVE FORMATIONS.

9 DETAIL VIEW OF OCEAN ROLLERS SHOWING THE EFFECT CAUSED BY WAVELETS AND SWIRLS.

10 PRELIMINARY STAGE FOR DETAIL SCENE OF EBBING TIDE.

11 FINISHED STAGE SHOWING THE GENTLE MOVEMENT OF AN EBBING TIDE ON BEACH.

12 PRELIMINARY STAGE OF WAVE BREAKING ON SHORE.

13 DETAIL STAGE OF WAVE BREAKING ON SHORE.

14 THE EFFECT OF SUNLIGHT ON RIPPLED WATER.

15 FIRST STAGE IN RIPPLED WATER EFFECT.

16 DETAIL STAGE IN RIPPLED WATER EFFECT. MAIN WAVES MERGE IN WITH MINOR WAVES DUE TO THE WHOLE SURFACE BEING MOVED BY LIGHT WINDS.

17 SLIGHTLY RIPPLED WATER CAUSES THIS TYPE OF REFLECTION

18

CLOUD FORMATIONS IN SEASCAPES

1 Head on view perspective lines of clouds.

2 Lines of clouds moving at an angle to the eye from vanishing point left.

3 Lines of clouds moving from vanishing point right.

Sketch your preliminary cloud lines the same as for sea and ocean, remember the rule of perspective applies to both, as well as everything else. The next three step illustrations show next stage in cloud construction, — you can see how the clouds get smaller in the distance.

4 Fine weather cumulus clouds shown in perspective.

5 Stratus clouds in perspective at an angle to the left.

6 Cirrus clouds in perspective at an angle to the right.

HERE ARE THREE MAIN TYPES OF CLOUD FORMATION.

7
FINE WEATHER CUMULUS
RAIN CUMULUS
FLUFFY FORMATION

CUMULUS

8
FLAT FORMATION

STRATUS

9
WISPY FORMATION

CIRRUS

10 CUMULONIMBUS

11 STRATOCUMULUS TRANSLUCIDUS

There are three main types of cloud formation, cumulus being the most used by artists in painting pictures, but there are several other names used for variations and link ups of clouds, quite apart from cumulus. There are some very pictorial formations which can make a sea-scape dramatic in quality, giving a supporting roll to the other elements.

12

STRATOCUMULUS

13

ALTOCUMULUS

Stratocumulus clouds form in layers of wavy patches or rolls and are gray in color.

Altocumulus clouds form in wavy patches, and have a translucent quality on the edges.

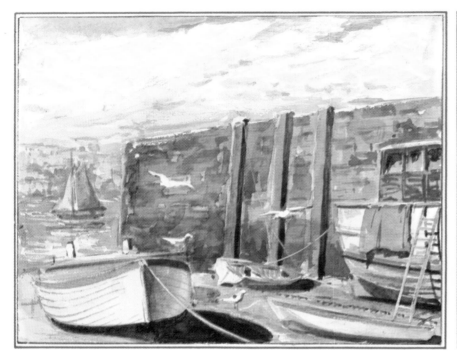

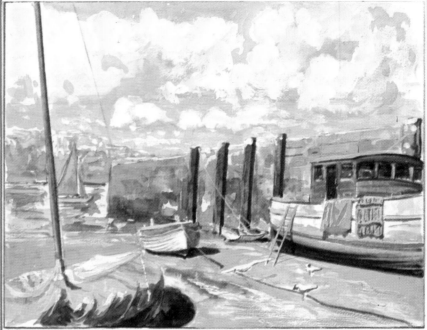

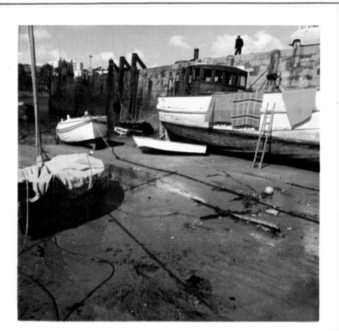

Illustrated on this page are four different compositions created from the recorded scene on one colored photograph. As you can see one does not have to copy a photograph exactly. Either for position of elements or for the coloring, but the quality of film is so excellent today, most artists find photography a big help. Always look upon the camera as a tool, not a rival, a servant, not a master, if the camera had been invented one, two or three centuries ago, I am sure the old masters would have made use of it to take much of the drudgery out of art. When doing a painting direct from nature or from a transparency or colored photograph, different artists see a picture in different ways, some have a leaning towards realism, which we call representational, others go more for atmospheric effect. This is called loose handling or impressionism, still others are interested in combining the two, personally I prefer this treatment, and so you will find all my paintings interpreted this way. Unlike the camera, the artist can subdue enhance, leave out unwanted portions, or idealize any subject at will, this is why a good painting is infinitely better than a photograph, it is a product of the soul.

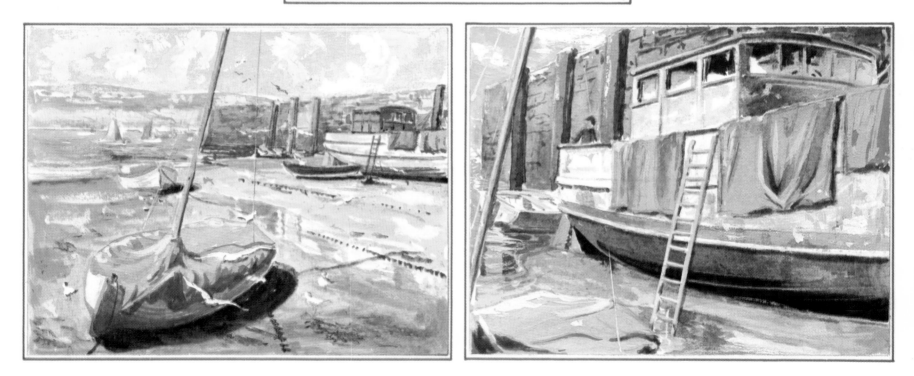

Walter Foster has published many fine books, several of which you will find invaluable as a guide to painting boats, you can use them in conjunction with this book, they describe various methods of treatment and techniques used by other artists, don't be overawed by the professional. Quality of the paintings illustrated, remember every artist was a beginner, and knowledge is continually being passed on and exchanged, every artist can learn something from his fellow artists, you may discover or evolve a new style which may well be adopted by others. The secret of success is constant study and practice.

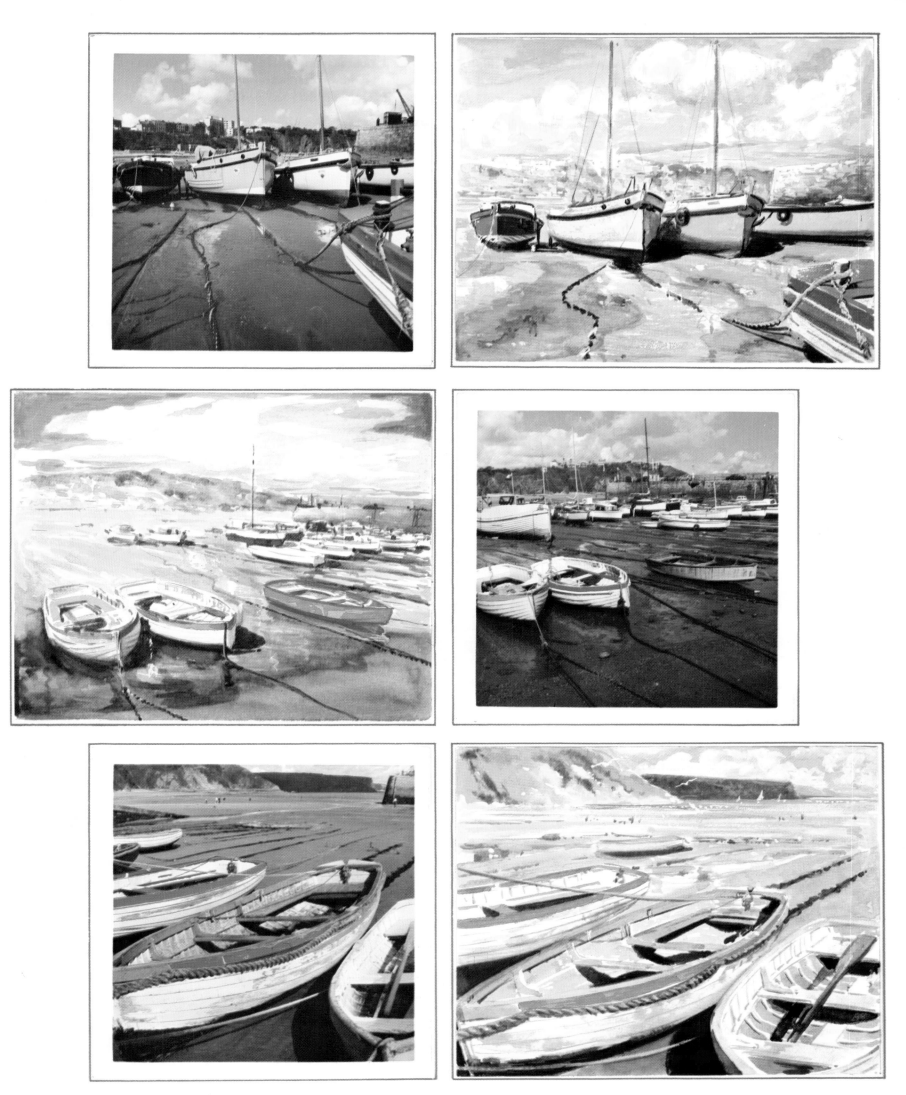

Here are some more colored prints taken in Tenby, a beautiful village in South Wales. Along side each print is a painting based on the recorded scene, colored prints are o.k. to work from, so long as you don't copy the color renderings because they are usually incorrect. Transparencies are more accurate. You will soon learn with practice to judge whether a color is correct. Try doing several compositions from each photograph as I have done on the facing page, you will find the results very interesting.

On this page I have illustrated a number of silhouettes of typical sail boats seen in the Western World, sail boats whether small or large, all have charm and each one will make a picture all the more interesting by adding life and movement to a painting, and I am sure you will enjoy painting them. No doubt some of you are the proud owners of your own boat, so you have the double enjoyment of sailing and painting.

OLD TIME GAFF RIGGED CUTTER

8 METRE YACHT

30 SQUARE METRES RACING YACHT

MODERN BERMUDIAN KETCH

MODERN BERMUDIAN CRUISING YAWL

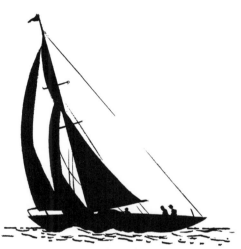

MODERN OCEAN RACING BERMUDIAN CUTTER

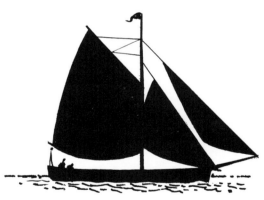

ITCHEN FERRY CUTTER

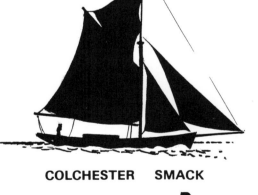

COLCHESTER SMACK

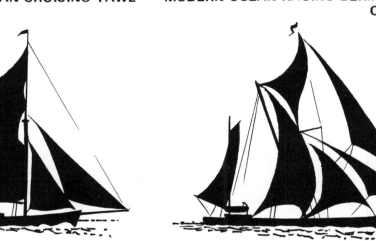

SEA GOING BARGE

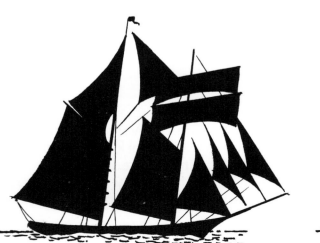

SCHOONER

BRIXHAM TRAWLER (GAFF KETCH)

TOP SAIL SCHOONER

In contrast to western type sail boats, I have illustrated a number of eastern sail boat silhouettes which look very different from sail boats more often seen in the western hemisphere, but though they look strange to western eyes, they are just as efficient and some can sail very fast. In an eastern setting they can look very picturesque, further on you will see some typical examples of paintings with an eastern atmosphere.

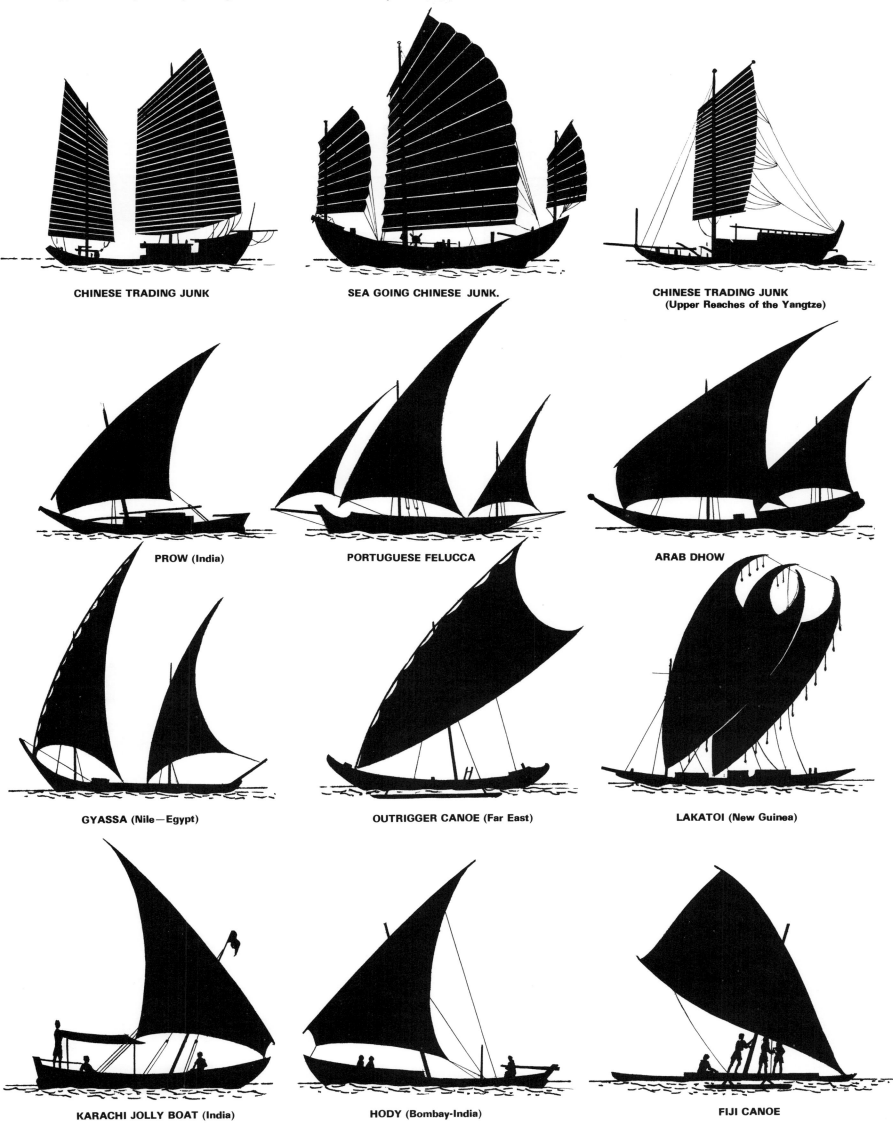

CHINESE TRADING JUNK

SEA GOING CHINESE JUNK.

CHINESE TRADING JUNK
(Upper Reaches of the Yangtze)

PROW (India)

PORTUGUESE FELUCCA

ARAB DHOW

GYASSA (Nile—Egypt)

OUTRIGGER CANOE (Far East)

LAKATOI (New Guinea)

KARACHI JOLLY BOAT (India)

HODY (Bombay-India)

FIJI CANOE

OPAQUE WATER COLOR TREATMENT (GUACHE)

STEP 1. Sketch in picture lightly, ready for first stage of painting, moisten whole area with water, blotting excess moisture.

STEP 2. Mix cobalt blue with white and touch of yellow ochre and run an opaque wash over sky, leaving white areas for clouds. Allow color to get paler towards horizon. Paint in cloud tones while blue sky is wet, and carefully soften parts of cloud edges, use a slight touch of raw sienna with white for light areas on clouds, raw umber and white for shadow areas, paint preliminary tones on distant coast grey and very pale green. Paint preliminary tone of viridian on water, leave white area for foam.

STEP 3. Continue to model clouds, paint in sails. Use raw umber, touch of green mixed with white for shadow areas on white sails, don't make too dark or heavy. Use touch of raw sienna, orange mixed with white for tan sails. Keep all your colors opaque in guache painting, if you do make a mistake, like with oils you can paint over it. Build up tones on coast line. Paint prussian blue toned down over viridian on water, paint in deck detail and masts.

STEP 4. Continue to build up tones on coast, boats, water. Paint in light blue tones on water in contrast to dark tones to get wave effect. Paint in form and rigging last. Keep water greenish where foam is breaking.

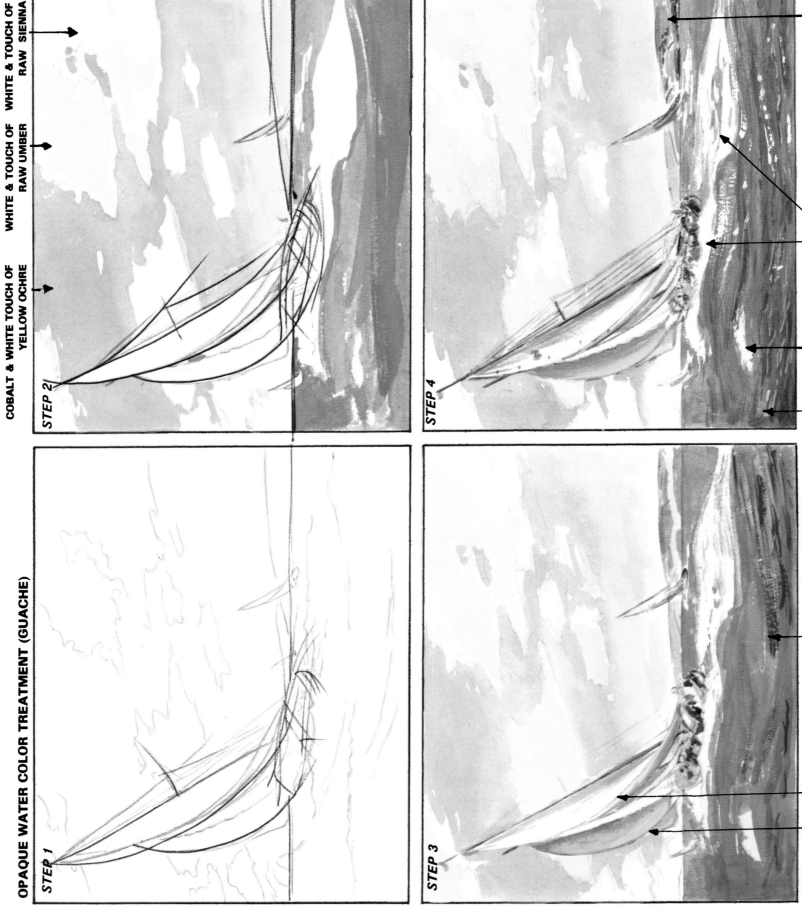

STEP 1

STEP 2

STEP 3

STEP 4

COBALT & WHITE TOUCH OF YELLOW OCHRE

WHITE & TOUCH OF RAW UMBER

WHITE & TOUCH OF RAW SIENNA

WHITE & TOUCH OF YELLOW OCHRE & ORANGE

RAW UMBER GREEN BLUE & WHITE

GREYED DOWN PRUSSIAN BLUE

GREYED DOWN GREEN

WHITE PALE GREEN UNDER FOAM

WHITE FOR FOAM & SPRAY

PRUSSIAN BLUE & WHITE

16

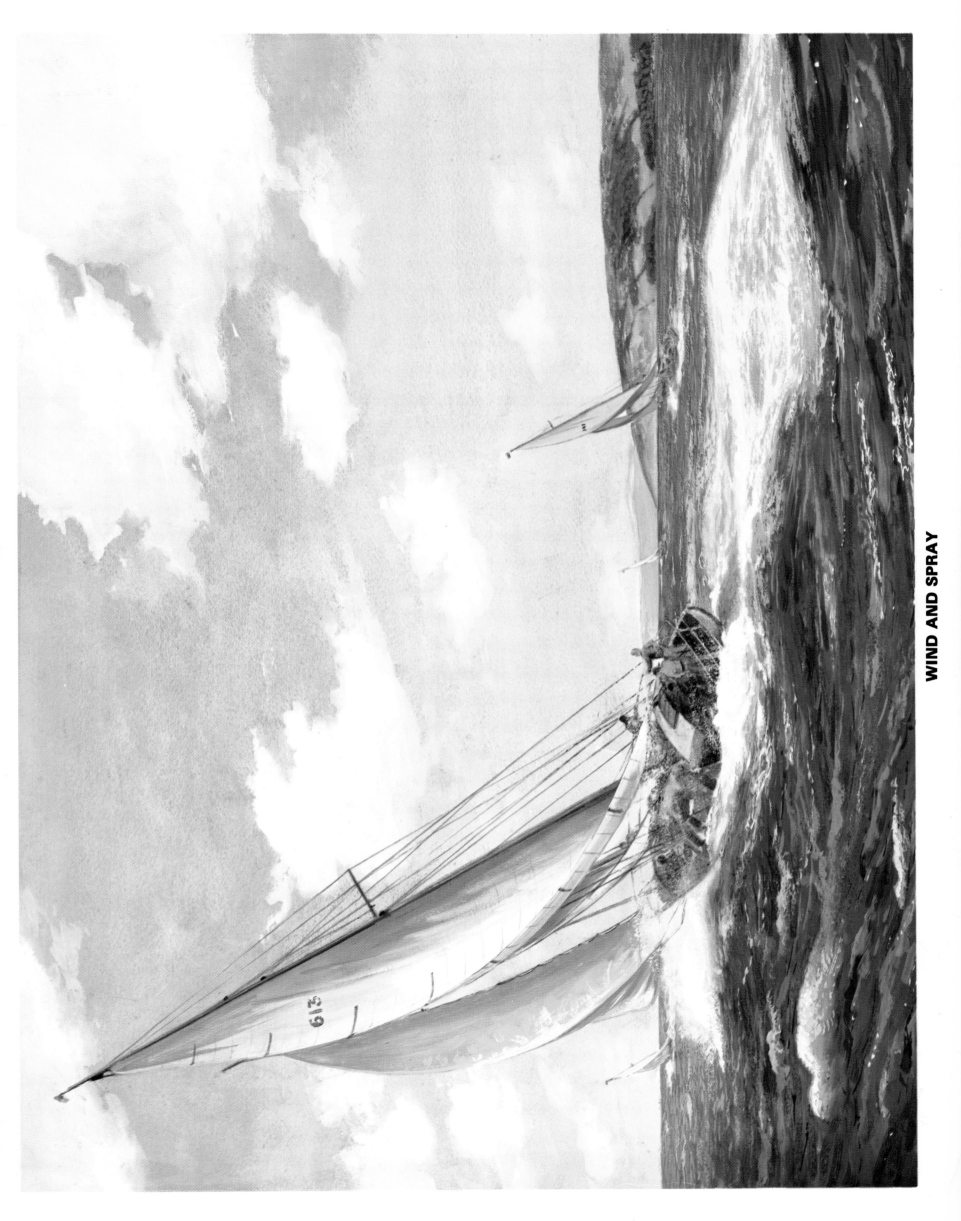

WIND AND SPRAY

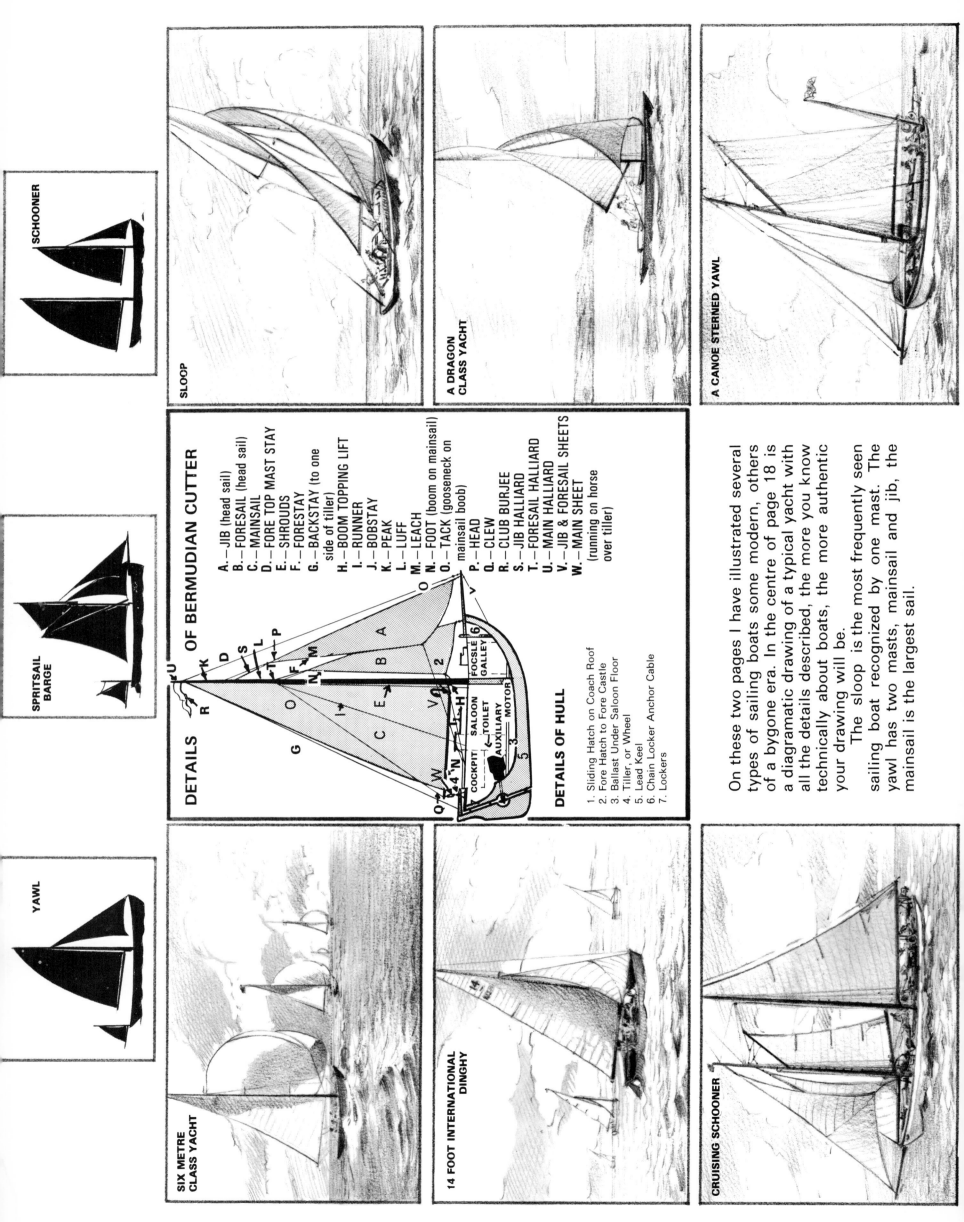

SCHOONER

SPRITSAIL BARGE

YAWL

SLOOP

A DRAGON CLASS YACHT

A CANOE STERNED YAWL

SIX METRE CLASS YACHT

14 FOOT INTERNATIONAL DINGHY

CRUISING SCHOONER

DETAILS OF BERMUDIAN CUTTER

A.—JIB (head sail)
B.—FORESAIL (head sail)
C.—MAINSAIL
D.—FORE TOP MAST STAY
E.—SHROUDS
F.—FORESTAY
G.—BACKSTAY (to one side of tiller)
H.—BOOM TOPPING LIFT
I.—RUNNER
J.—BOBSTAY
K.—PEAK
L.—LUFF
M.—LEACH
N.—FOOT (boom on mainsail)
O.—TACK (gooseneck on mainsail boob)
P.—HEAD
Q.—CLEW
R.—CLUB BURJEE
S.—JIB HALLIARD
T.—FORESAIL HALLIARD
U.—MAIN HALLIARD
V.—JIB & FORESAIL SHEETS
W.—MAIN SHEET
(running on horse over tiller)

DETAILS OF HULL

1. Sliding Hatch on Coach Roof
2. Fore Hatch to Fore Castle
3. Ballast Under Saloon Floor
4. Tiller, or Wheel
5. Lead Keel
6. Chain Locker Anchor Cable
7. Lockers

FOCSLE
GALLEY
SALOON
TOILET
AUXILIARY MOTOR
COCKPIT

On these two pages I have illustrated several types of sailing boats some modern, others of a bygone era. In the centre of page 18 is a diagramatic drawing of a typical yacht with all the details described, the more you know technically about boats, the more authentic your drawing will be.

The sloop is the most frequently seen sailing boat recognized by one mast. The yawl has two masts, mainsail and jib, the mainsail is the largest sail.

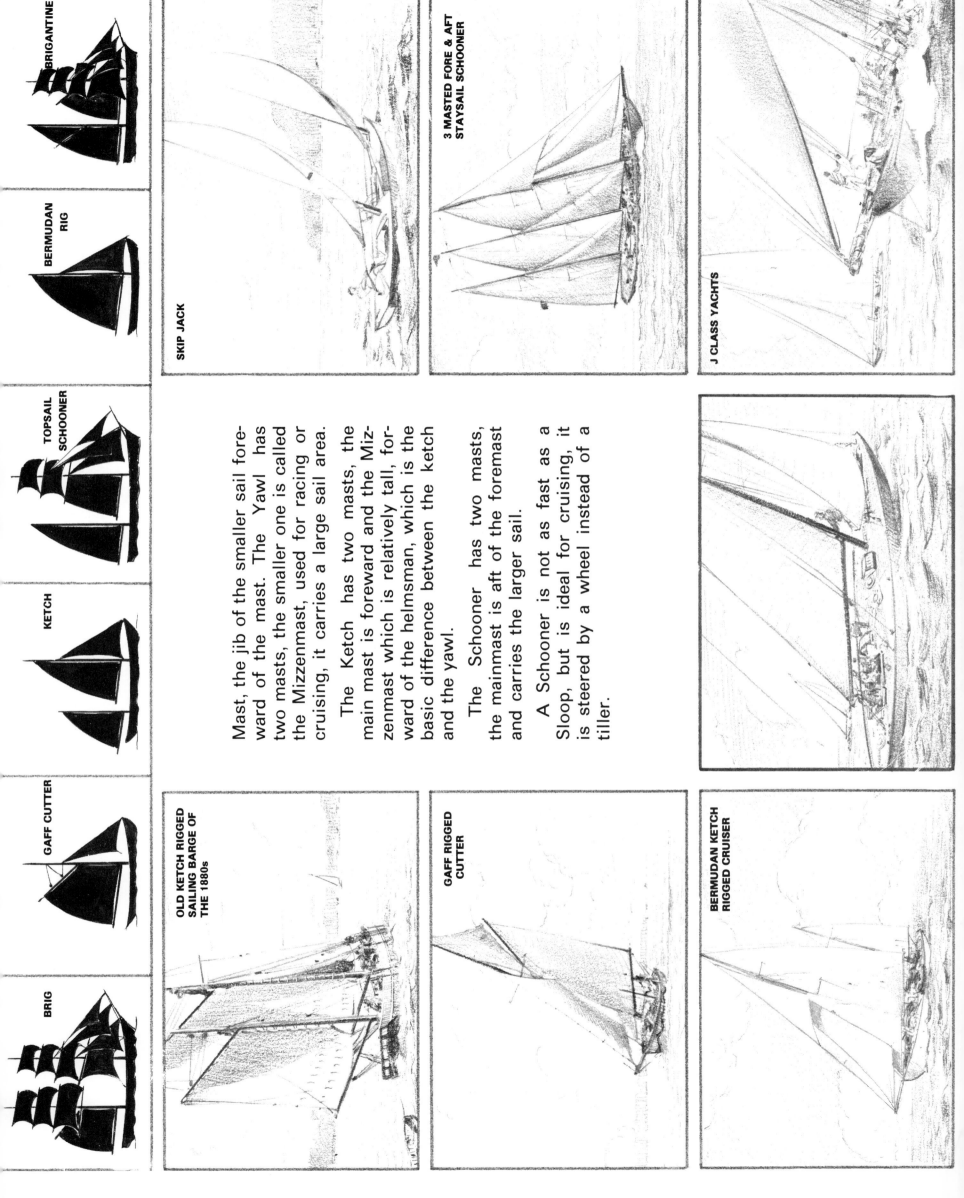

BRIGANTINE

BERMUDAN RIG

TOPSAIL SCHOONER

KETCH

GAFF CUTTER

BRIG

SKIP JACK

3 MASTED FORE & AFT STAYSAIL SCHOONER

J CLASS YACHTS

OLD KETCH RIGGED SAILING BARGE OF THE 1880s

GAFF RIGGED CUTTER

BERMUDAN KETCH RIGGED CRUISER

Mast, the jib of the smaller sail foreward of the mast. The Yawl has two masts, the smaller one is called the Mizzenmast, used for racing or cruising, it carries a large sail area.

The Ketch has two masts, the main mast is foreward and the Mizzenmast which is relatively tall, foreward of the helmsman, which is the basic difference between the ketch and the yawl.

The Schooner has two masts, the mainmast is aft of the foremast and carries the larger sail.

A Schooner is not as fast as a Sloop, but is ideal for cruising, it is steered by a wheel instead of a tiller.

19

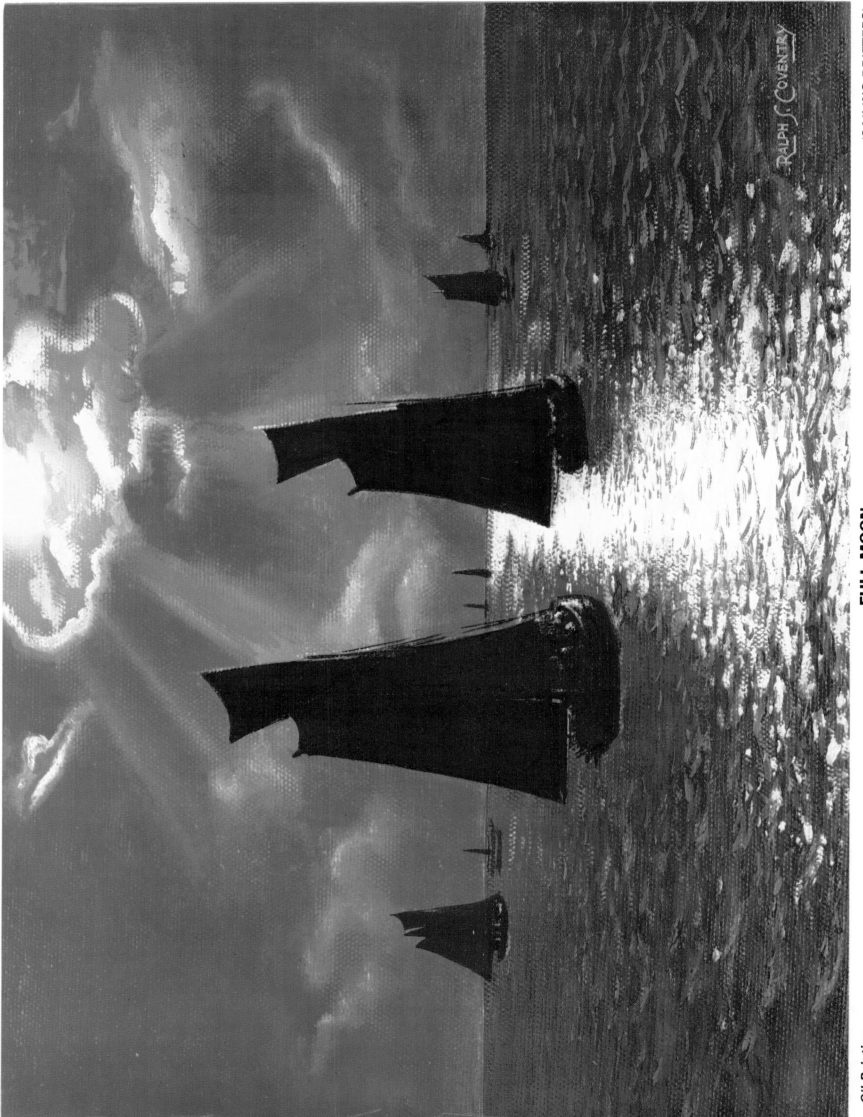

Oil Painting

FULL MOON

(SAILING DRIFTERS)

20

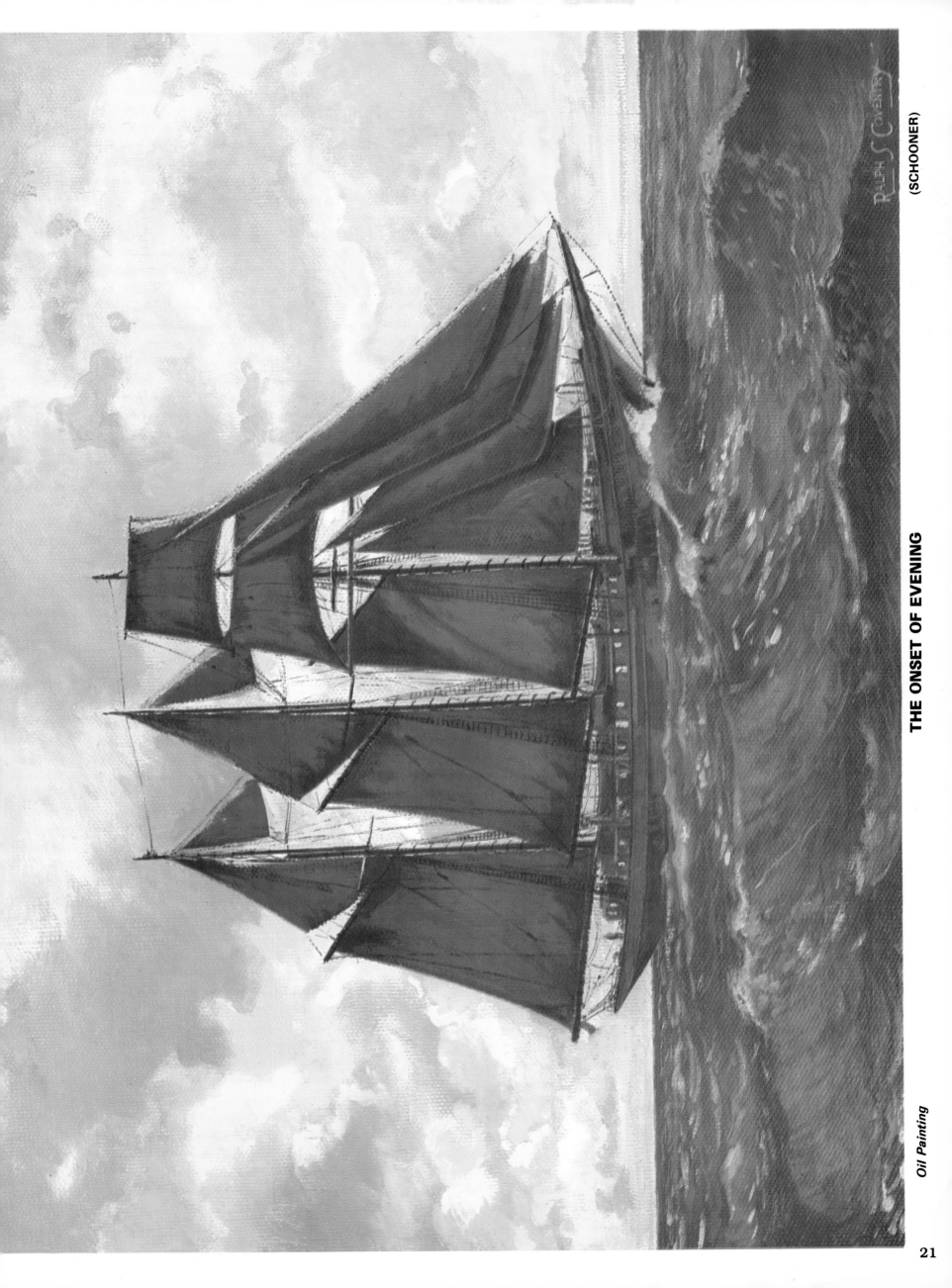

RALPH S COVENTRY

(SCHOONER)

THE ONSET OF EVENING

Oil Painting

21

LIGHTED BELL BUOY. U.S.A.

LIGHTED ACETYLENE GAS BUOY. TYPE 2. U.K.

LIGHTED ACETYLENE GAS BUOY TYPE 1. U.K.

A WRECK BUOY. U.K. COLOR BRIGHT GREEN

PORTHAND OR NUN BUOY. COLOR RED & WHITE

A STARBOARD OR CAN BUOY. U.K. COLOR. BLACK.

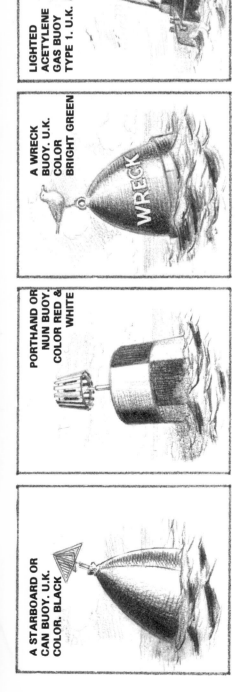

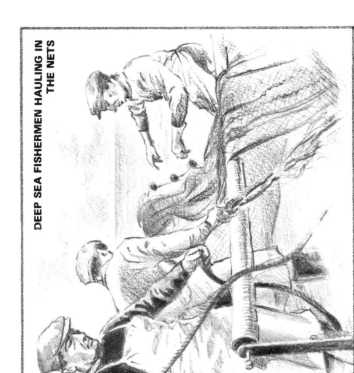

DEEP SEA FISHERMEN HAULING IN THE NETS

Typical sights and objects to be seen around fishing villages and harbours are illustrated on this page. They add variety and color to marine paintings.

Develop a keen sense of observation. All over the world you will find wonderful things of interest. Although their shapes may vary, different countries have their own pet shapes and forms, but basically they are much the same and all serve the same or similar purpose. Always have your camera or sketch book with you. This way you can record and build up a valuable reference source of material for future painting. And you will cultivate a good memory which is time saving. You will find you will be able to put your finger on just the piece of reference you require.

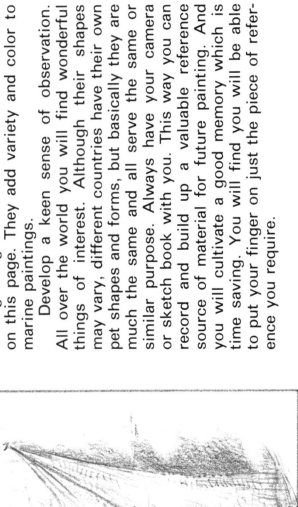

FISHERMAN CHECKING HIS FISHING NET

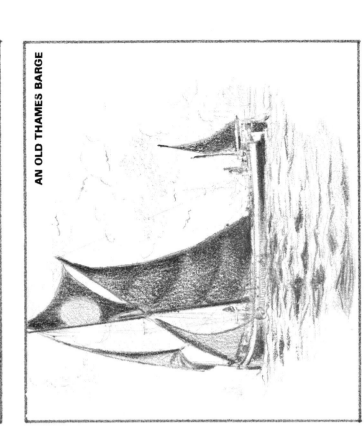

AN OLD THAMES BARGE

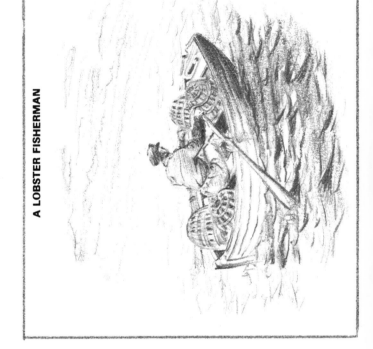

A LOBSTER FISHERMAN

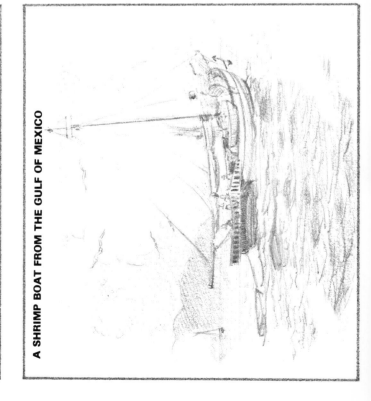

A SHRIMP BOAT FROM THE GULF OF MEXICO

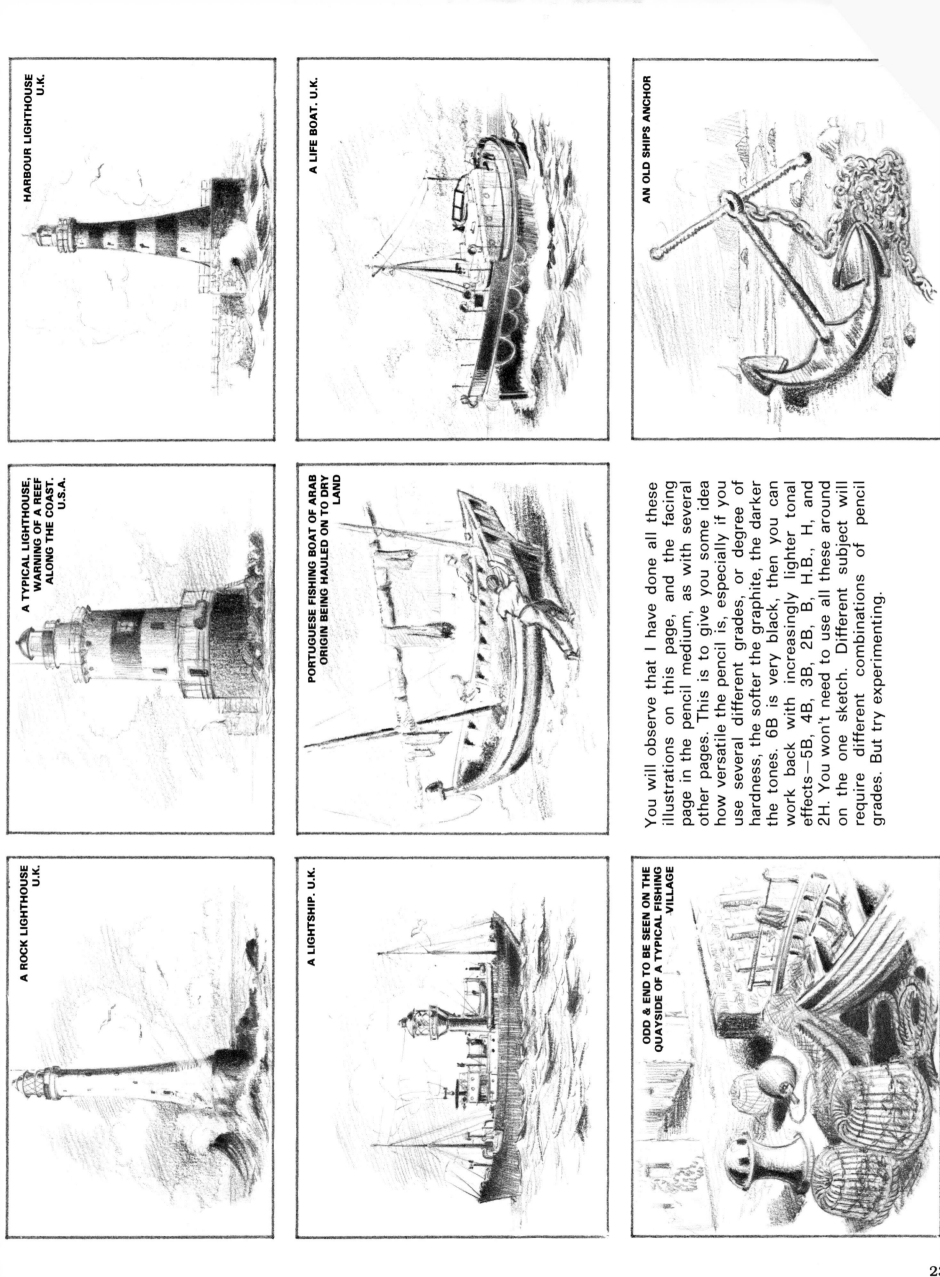

HARBOUR LIGHTHOUSE
U.K.

A LIFE BOAT. U.K.

AN OLD SHIPS ANCHOR

A TYPICAL LIGHTHOUSE, WARNING OF A REEF ALONG THE COAST. U.S.A.

PORTUGESE FISHING BOAT OF ARAB ORIGIN BEING HAULED ON TO DRY LAND

You will observe that I have done all these illustrations on this page, and the facing page in the pencil medium, as with several other pages. This is to give you some idea how versatile the pencil is, especially if you use several different grades, or degree of hardness, the softer the graphite, the darker the tones. 6B is very black, then you can work back with increasingly lighter tonal effects—5B, 4B, 3B, 2B, B, H.B., H, and 2H. You won't need to use all these around on the one sketch. Different subject will require different combinations of pencil grades. But try experimenting.

A ROCK LIGHTHOUSE
U.K.

A LIGHTSHIP. U.K.

ODD & END TO BE SEEN ON THE QUAYSIDE OF A TYPICAL FISHING VILLAGE

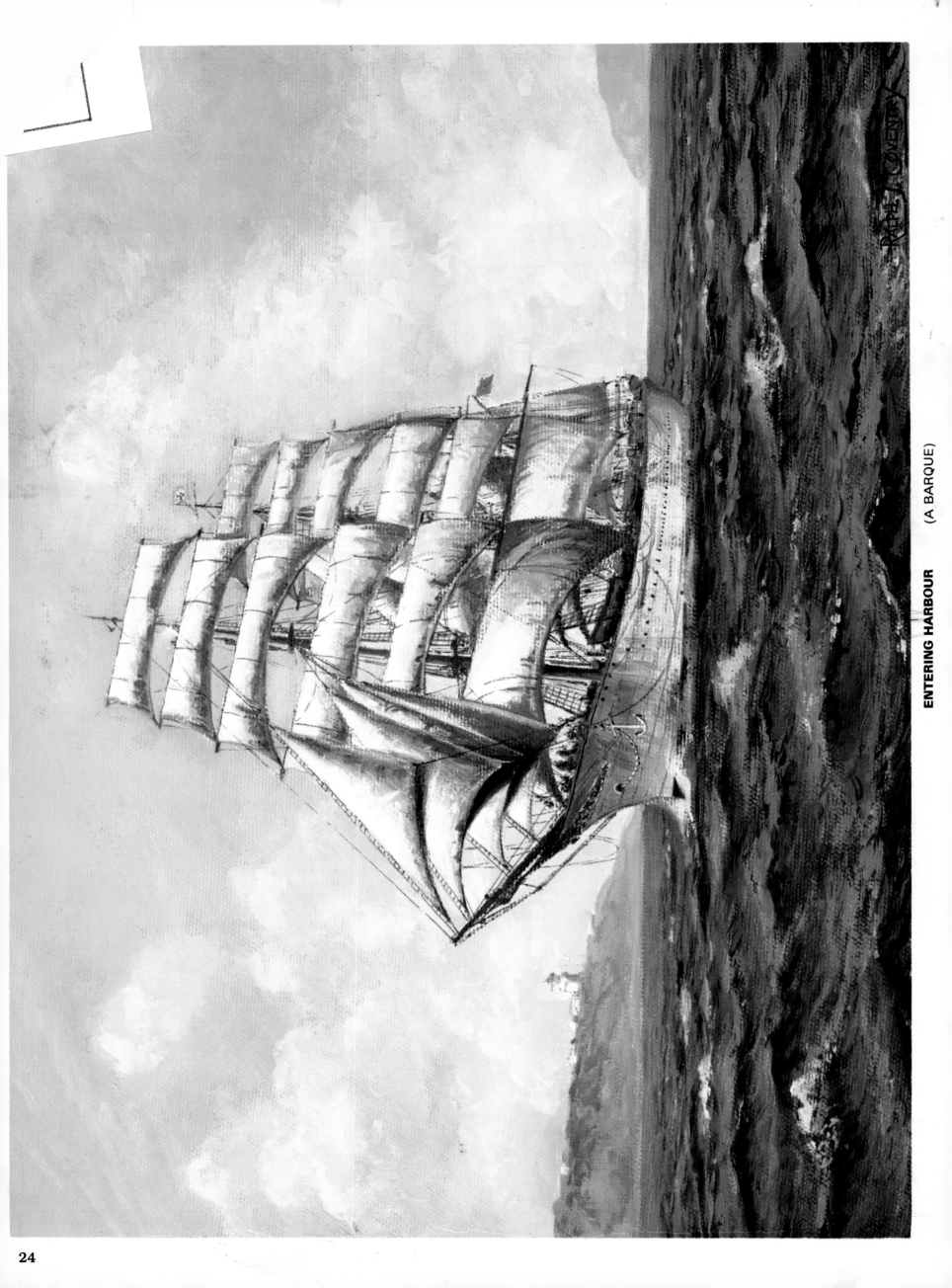

ENTERING HARBOUR (A BARQUE)

24

JOURNEY UP THE NILE

(ARAB DHOWS)
MIDDLE EAST

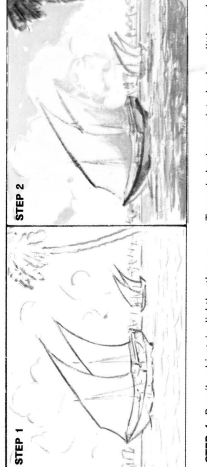

STEP 1

STEP 2

STEP 1. Pencil subject in lightly, then go over in thin blue outline, ready for painting in the preliminary tones.

STEP 2. Paint in sky, mixture of Prussian blue and white greyed down a little, add touch of Viridian.

Towards horizon, paint clouds a little cadmium yellow mixed with white. Indian red, touch of blue mixed with white for cloud shadows. Cadmium yellow and white for sails, raw umber, blue and white for shadows. Burnt sienna and white on hull - pale blue base for water, gradually build up tones.

STEP 1 Pencil subject in lightly, then go over in thin outline of blue, ready for painting in the preliminary tones.

STEP 2 Paint in sky Prussian blue, with white, and greyed down, add touch of viridian towards horizon.

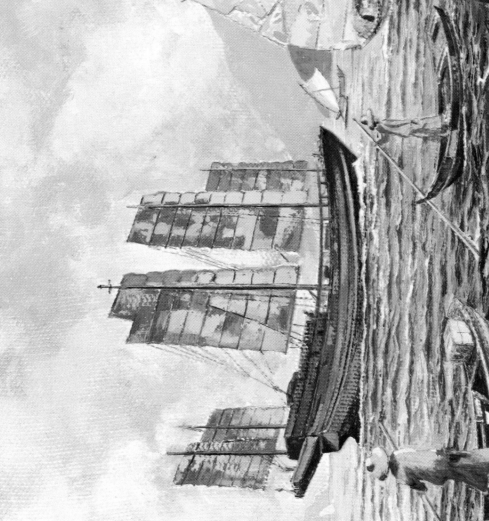

A BUSY HARBOUR IN THE ORIENT (CHINESE JUNKS)

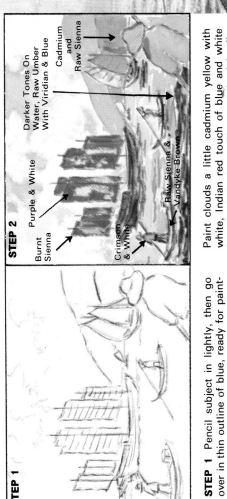

STEP 1

STEP 2

Burnt Sienna

Purple & White

Darker Tones On Water, Raw Umber With Viridian & Blue

Cadmium and Raw Sienna

Raw Sienna & Vandyke Brown

Crimson & White

Paint clouds a little cadmium yellow with white, Indian red touch of blue and white for cloud shadows. Blue grey land in distance, darker for nearest land. Burnt sienna, orange and white for sails on large junk with yellow and purple patches in light areas. Pale yellow and raw umber with white for small junk sails, gradually build up tones.

25

Towards the end of the 19th century the barque rig became to be accepted as having better sailing qualities than the typical full rigged clipper. The difference between the barque rig and the full rigged clipper, is that the barques mizzenmast had fore and aft sails only, thus requiring a smaller crew. The speed of the barque was less than the clipper, but they could carry much more cargo. As with clippers, several barques are still used as sea going school ships. The following are the names of some, Ex Horst, Wessel (U.S.A.), Sedov (U.S.S.R.) Sagres, (Portugal) Galatea (Spain).

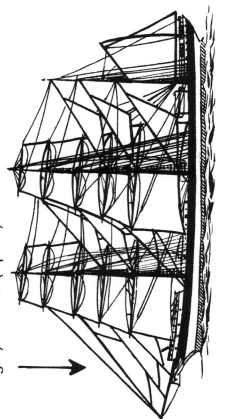

THREE MASTED BARQUE

The brig is a sailing ship with two masts, smaller in size than the full rigged clipper, or barque, used mainly for coastal trading, and short sea traders of the 19th century.

Other variations of the sailing ship are the three masted top sail schooner, the brigantine, the barquentine, the portuguese ketch and the Greek Caique.

I have included some of these beautiful vessels in the full color marine paintings, shown in this book. Have a go at painting one yourself.

At the top center of page is the typical rig of a sailing ship which I have included.

Although this book shows mainly illustrations of small sail craft, it would not be complete without showing some of the beautiful sailing ships that once dominated the oceans of the last century. I have shown here three examples of the sailing ship. Probably the most beautiful of all sailing ships was the clipper, some of which became famous.

THE SAILING SHIP

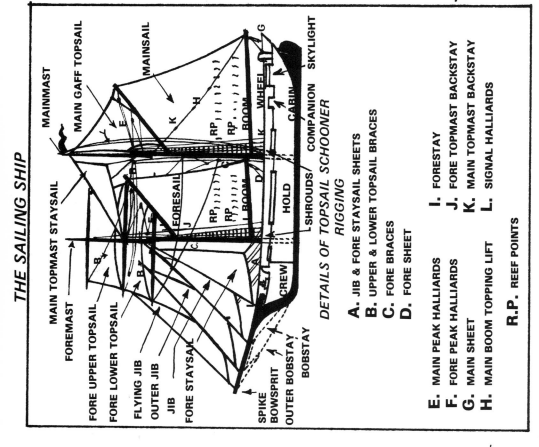
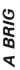

MAINMAST
MAIN GAFF TOPSAIL
MAINSAIL
MAIN TOPMAST STAYSAIL
FOREMAST
FORE UPPER TOPSAIL
FORE LOWER TOPSAIL
FLYING JIB
OUTER JIB
JIB
FORE STAYSAIL
FORESAIL
SPIKE
BOWSPRIT
OUTER BOBSTAY
BOBSTAY
WHEEL
CABIN
BOOM
BOOM
HOLD
CREW
SHROUDS
COMPANION
SKYLIGHT
REEF POINTS
RP

DETAILS OF TOPSAIL SCHOONER RIGGING

A. JIB & FORE STAYSAIL SHEETS
B. UPPER & LOWER TOPSAIL BRACES
C. FORE BRACES
D. FORE SHEET

E. MAIN PEAK HALLIARDS
F. FORE PEAK HALLIARDS
G. MAIN SHEET
H. MAIN BOOM TOPPING LIFT

I. FORESTAY
J. FORE TOPMAST BACKSTAY
K. MAIN TOPMAST BACKSTAY
L. SIGNAL HALLIARDS

R.P. REEF POINTS

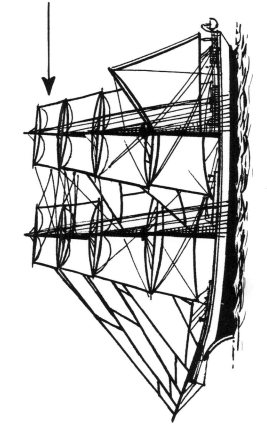

A BRIG

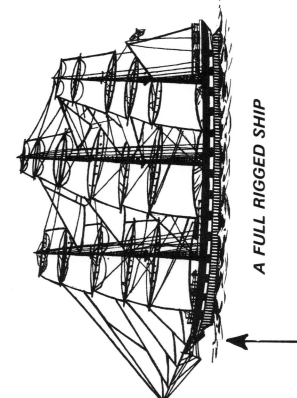

A FULL RIGGED SHIP

The sight of a 19th century tea clipper in full sail and moving at 16 knots, is a magnificent sight. Many paintings have been done of these fine old sailing ships, and it is a great pity that they are no longer used in large numbers. Fortunately there are still some left. A few are used as school training ships. Among many of the famous tea clippers were the names of Cutty Sark, Taeping, Ariel, Sir Launcelot, Fiery Cross and Thermopylae.

PAREJA (SPANISH)

STEAM POWERED WHALE CATCHER (U.K.)

TRAWLER (U.K.)

STEAM DRIFTER (U.K.)

Here we have a page of fishing craft. Some are sail boats, others have sail and auxiliary power. The trawlers are steam powered. They are attractive little boats and are good subjects for pictures.

There are many different kinds of fishing craft. They all differ in detail according to the work they do, the method of fishing, and the country of origin. This page has nine examples of them.

NET

FISH HAULED IN THIS DIRECTION

DIRECTION OF TIDE

PAREJAS

PAREJA FISHING (SPANISH)

DETAILS OF STEAM TRAWLER (OLD TYPE)

MIZZEN
SAIL
GALLEY

GALLOWS

OFFICERS
ENGINE
ROOM

WHEEL HOUSE
TRAWL
WINCH

BOILER

COAL

FISH
HOLD

ICE

STORE

CREW

GALLOWS

This type of trawler was typical of many used in the North Sea between Great Britain & Scandinavia, more modern types are used now.

ANCHOR
BUOY

BOAT

WARPS

SEINE NET

FISH HAULED IN THIS DIRECTION.

DIRECTION OF TIDE

SEINING (DANISH)

BUOYS

CORK FLOAT

LEAD WEIGHTS

MESSENGER-ROPE

DRIFTING (BRITISH)

WARPS

OTTER BOARDS

TRAWLING (BRITISH)

DUTCH HOOGAARS

SARDINE LUGGER (FRENCH)

CRAB CUTTER (FRENCH)

DEEP SEA KETCH (DANISH)
Auxiliary Powered Fishing Boat

INSHORE CUTTER (DANISH)

STEP 1. Carefully pencil in subject lightly.

STEP 2. Go over pencil outline in thin blue paint, this makes it easier to place your main color areas. Paint in sky, prussian blue with white and greyed down. Add touch of viridian towards horizon. Paint costal background in pale yellow green mixed with white.

STEP 3. Add green grey tones to coastline paint in preliminary tones on sails orange greyed down with white. Green sails also greyed down with white light sail patches, raw sienna mixed with white.

STEP 4. Add clouds to sky after the blue part has had time to dry. White with touch of raw sky effect, touch of india red and blue in shadows. Touch of raw sienna and white in lightest areas. Blend in colors keep soft and pale. Paint hulls on boat a grey brown. Touches of blue grey in patches. Paint water pale prussian blue and viridian. Mix with white always to keep greyed down, otherwise colors will look raw. Gradually build up tones all over picture touch of black will darken most colors for shadows, but with yellow always use burnt umber which keeps the color from looking dirty. Water shadows. Mixture of raw umber, viridian and blue. Blue grey shadows on white sails of small boat. Add white to water last. Paint masts, etc., in burnt sienna. For shadow, yellow orange highlights. But keep all colors subdued by mixing with white or black.

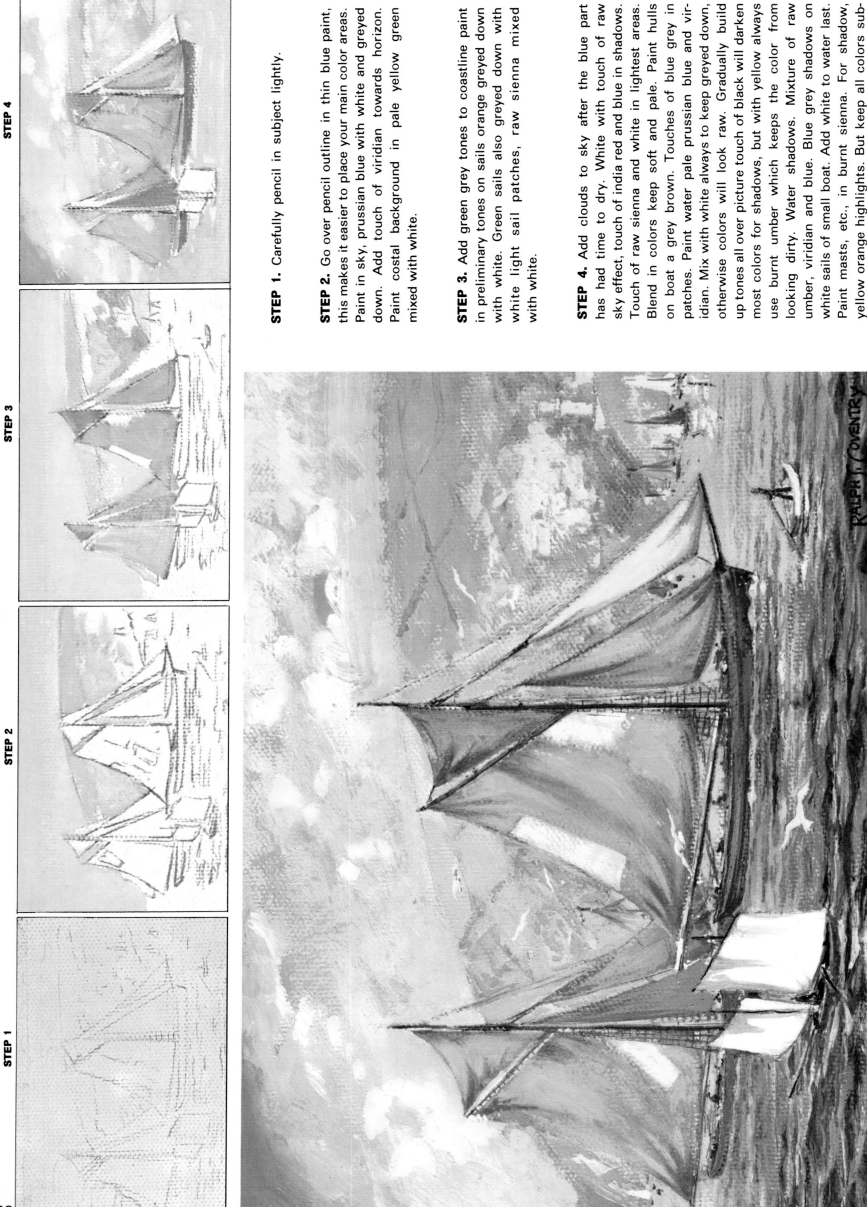

SAILING TRAWLERS & CRABBER

COMBINATION TRANSPARENT WATER-COLOR & GUACHE

STEP 1. Sketch in lightly the main elements of your picture, then dampen the whole area, blotting excess water, ready for washing in.

STEP 2. Wash in sky with cobalt blue, starting slightly darker at top of picture and gradually getting paler, and a little greener towards horizon, use viridian to give greenish cast. Wash in distant coast line, mixture of ultramarine and cadmium yellow for fields and foliage, indian red with touch of blue for the rock cliffs. Paint in preliminary tone of viridian green on sea, leaving areas of white to suggest foam.

STEP 3. Wash in shadow areas of clouds with mixture of cobalt blue and indian red. Mix white, touch of green and raw umber for main sails and smaller one. Mix touch of blue, raw umber and white, for spinnaker. Paint in deck details, hull, figures, etc. Tones of raw umber, sepia, blue, grey on figures and general detail.

STEP 4. Run a pale wash of cadmium yellow over clouds. This will produce a warm effect. Paint in second tone on water, of French ultramarine, modeling the waves, allow some of green to show through, especially under white foam and edges. Paint shadow side of waves with mixture of viridian and rose madder. Show reflection of sails in water with raw sienna and white, finish off painting by working up detail and rigging, etc. By running a pale semi-opaque wash of white over background you can emphasize distance.

A HAZY DAY

29

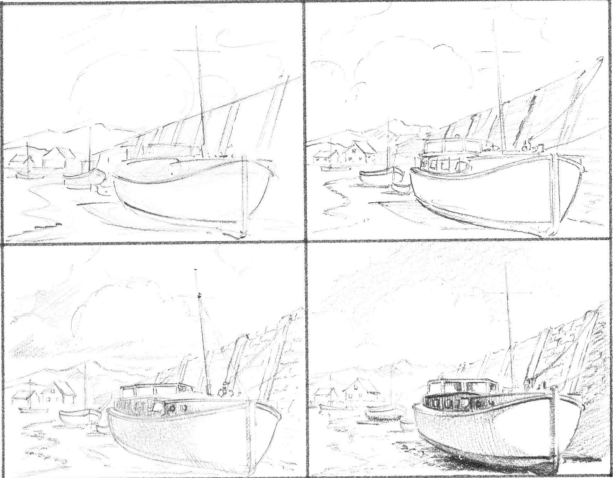

Try this pencil drawing exercise. The four step drawings show you the simple step by step development to the finished stage. Use different grades of pencils in the one sketch The softer the graphite the darker the tones.

The following grades are most suitable starting from H which is hard then H.B., B, 2B, 3B, 4B, 5B, 6B, ending with the darkest tone. F is also a useful grade about as firm as H.B. but darker. There are several good books on the market which explains the technique of pencil drawing more fully.

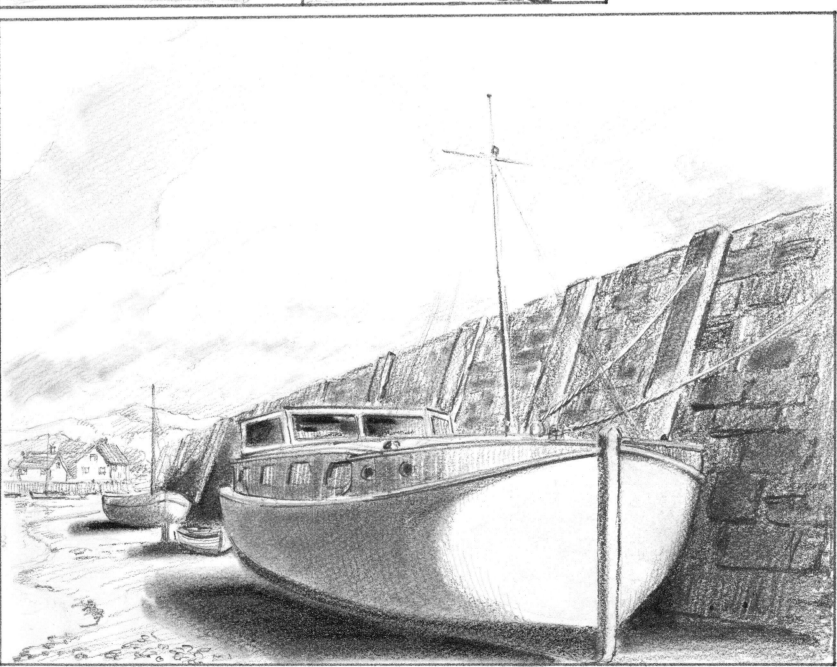

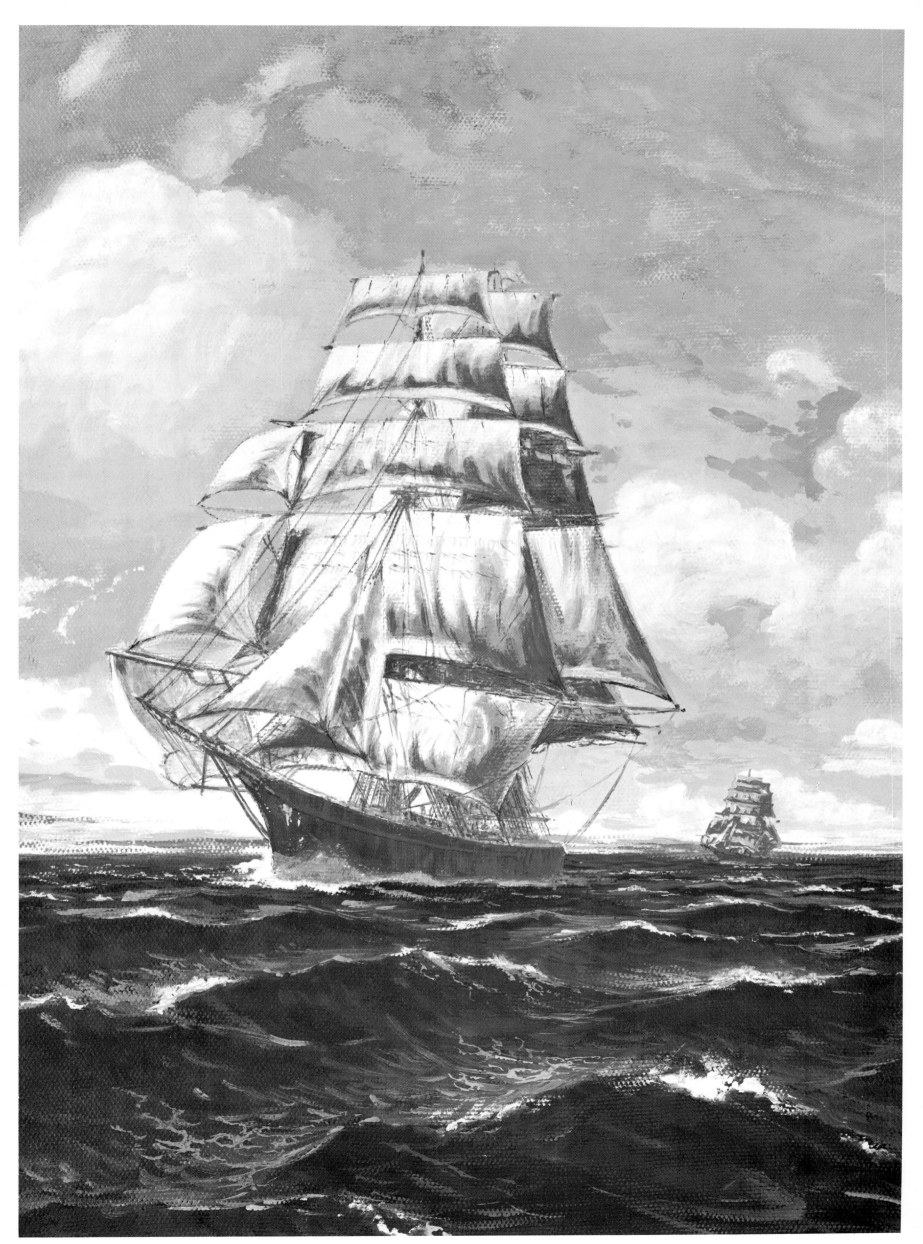